General Editor
David Piper

Rembrandt
Every Painting II

Christopher Brown
Deputy Keeper, National Gallery, London

NEW YORK

Foreword by the General Editor

Several factors have made possible the phenomenal surge of interest in art in the twentieth century: notably the growth of museums, the increase of leisure, the speed and relative ease of modern travel, and not least the extraordinary expansion and refinement of techniques of reproduction of works of art, from the ubiquitous colour postcards, cheap popular books of colour plates, to film and television. A basic need – for the general art public, as for specialized students, academic libraries, the art trade – is for accessible, reliable, comprehensive accounts of the works of the individual great masters of painting; this has not been met since the demise before 1939 of the famous German series, *Klassiker der Kunst*; when such accounts do appear, in the shape of full *catalogues raisonnés*, they are vast in price as in size, and beyond the reach of most individual pockets and the capacity of most private bookshelves.

The aim of the present series is to provide an up-to-date equivalent of the *Klassiker* for the now enormously enlarged public interested in art. Each volume (or volumes, where the quantity of work to be reproduced cannot be contained in a single one) catalogues and illustrates chronologically the complete paintings of the artist concerned. The catalogues reflect as far as possible a consensus of current expert opinion about the status of each picture; in the nature of things, consensus has yet to be reached on many points, and no one professionally involved in the study of art-history would ever be so rash as to claim definitiveness. Within the bounds of human fallibility, however, every effort has been made to achieve both comprehensiveness and factual accuracy, while the quality of reproduction aimed at is the highest possible in this price range, and includes, of course, colour. Every effort has also been made to hold the price down to the lowest possible level, so that these volumes may stay within the reach not only of libraries, but of the individual student and lover of great painting, so that they may gradually accumulate their own 'Museum without Walls'. The introductions, written by acknowledged authorities, summarize the life and works of the artists, while the illustrations place in perspective the complete story of the development of each painter's genius through his career.

David Piper

Introduction

For four or five years after Rembrandt's arrival in Amsterdam in 1632, he concentrated almost exclusively on portrait painting and there can be little doubt that at that time he was the most sought-after portraitist in the city. Rembrandt considered himself, however, a history painter in the first place and in the last years of the decade the hectic output of portraits slackened as he returned to the depiction of Biblical, mythological and classical scenes which had first won for him the attention of important patrons during his earliest years in Leiden.

From about 1636 onwards Rembrandt painted only occasional portraits, never again devoting himself entirely to their production. He often painted people with whom we know him to have had a personal contact. From 1641 date a pair of his finest portraits, *Agatha Bas* (No. 213; London, Royal Collection) and her husband *Nicolaes van Bambeeck* (No. 212; Brussels, Musée des Beaux-Arts). In 1631 Bambeeck lived with his mother in the Sint Anthonisbreestraat, a few houses from Gerrit van Uylenburch, with whom Rembrandt was lodging. Bambeeck was one of a group of wealthy Amsterdammers (Rembrandt was another) who in 1640 advanced money to Uylenburch to finance his dealing. It may well have been this personal contact which caused Rembrandt to paint the portraits of Bambeeck and his wife at a time when he was rarely accepting portrait commissions.

Another portrait of 1641 is the extraordinary picture of the famous Mennonite preacher Cornelis Claesz. van Anslo (No. 218; Berlin, Gemäldegalerie). Anslo had sat to Rembrandt for two portrait drawings in 1640, and he used the drawings in the first place for an etched portrait of 1641. That portrait prompted the Dutch poet Joost van den Vondel to write a poem: 'On Cornelis Anslo. Rembrandt should paint the voice of Cornelis, for his outward appearance is the least of him; the invisible can only be known through the ears. He who wants to see Anslo must hear him.' Rembrandt's painted portrait which shows the preacher open-mouthed and gesticulating, expounding from the Bible to

an attentive woman, seems to be a deliberate response to Vondel's challenge to paint Cornelis's voice.

In the following year – 1642, the year of Saskia's death – Rembrandt painted a great work of his maturity, *The Night Watch*, properly called *The Militia Company of Captain Frans Banning Cocq* (No. 223; Amsterdam, Rijksmuseum). The popular title of this, the best known of all Rembrandt's paintings, dates from the nineteenth century when the varnish on the picture had darkened considerably so that the scene appeared to be taking place at night. Recent cleaning has revealed that the scene is quite clearly taking place during the daytime.

The commission most probably came from Captain Banning Cocq himself: he is the central figure, dressed in black. In his family album, now displayed near the picture in the Rijksmuseum, a seventeenth-century drawn copy of the picture is described as 'a sketch of

Self-portrait in artist's smock: drawing, pen and bistre, 20.3 × 13.4 cm, c.1654; Amsterdam, Rembrandthuis. Inscription on the strip (added later) reads: by Rembrandt van Rijn of himself as he was dressed in his studio.

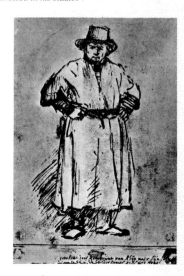

the picture in the great room of the Civic Guards' House [Kloveniersdoelen], in which the young lord of Purmerlandt [Banning Cocq] as captain gives orders to the lieutenant [William van Ruytenburgh, in yellow] to have his company march out'. The militia companies, or civic guards, which during the early days of the long war with Spain had an important military function, had by 1642 acquired instead a principally social significance. Many group portraits of the companies survive (notably those of the Haarlem companies by Frans Hals, today hanging in the Frans Hals Museum in Haarlem) but Rembrandt's treatment of them 'marching out' was entirely novel, as they were usually portrayed standing stiffly in rows or gathered around a dinner table. It is the dynamic composition, in which Rembrandt uses all the baroque devices to lead the eye around the picture, causing it to zigzag across the picture from areas of dark to light, that makes it so effective. The best description of the painting remains the one given by Rembrandt's pupil Samuel van Hoogstraten in 1678. Painters should not, as he writes, as painters of group portraits had done formerly, place their sitters in rows. The best masters create a unified composition. 'Rembrandt observed this,' he continued, 'excellently in his militia piece in Amsterdam, too much in the view of many, paying greater heed to the sweep of his imagination than to the individual portraits he was required to do. Yet this work, no matter how much it can be censured [Hoogstraten was writing in the classicist climate of the 1670s] will survive all its competitors because it is so painterlike in thought, so dashing in movement, and so powerful that according to some all the other pieces there [in the Kloveniersdoelen] stand beside it like playing cards.' Early copies of the painting show that it was cut down on all sides (most severely on the left and at the top) when it was moved to the smaller War Council Chamber in the Town Hall in Amsterdam in 1715.

Behind the two officers is the colour sergeant Jan Cornelisz. Visscher and two other sergeants to left and right. Although the commission probably came from Banning Cocq, sixteen of the Civic Guard officers and other ranks paid about 100 guilders each towards the cost of the painting, 'the one more, the other less, according to their placing in the picture'. The unconventional character of the painting has prompted many more questions. Although, for example, we know that sixteen members of the militia company paid for the picture, there are in fact twenty-eight adults and three children represented. Which are portraits and which not? Why did Rembrandt include all those extraneous figures? What is the meaning of the girl who has a fowl tied to her waist? One theory which claims to answer these and other questions is that Rembrandt modelled the painting on a production of Vondel's play Gysbrecht van Amstel which had been recently performed in Amsterdam. He is said to have represented Banning Cocq in the guise of Gysbrecht, a legendary hero of Amsterdam. While it is true that Rembrandt did make drawings of actors who performed in the play, this theory is not entirely convincing. Another problem is raised by the architecture: although presumably meant to represent the Kloveniersdoelen, it appears to have been based on engravings after Raphael.

Despite the unusual nature of The Night Watch, there is no evidence whatsoever to support the old legend that the picture represents a turning-point, for the worse, in Rembrandt's fortunes. The members of the company were perfectly satisfied with the picture which they hung proudly alongside the other militia pieces in the Kloveniersdoelen.

Since his earliest years in Leiden, when he had his first pupil, Gerrit Dou, Rembrandt's studio had been full of young painters. Joachim Sandrart, who was in Amsterdam between 1637 and 1641, wrote later (1675): 'Rembrandt was a very industrious man and he worked relentlessly, and Fortune made him wealthy and filled his house in Amsterdam with almost countless distinguished children who came for instruction and learning, of whom every single one paid him 100 guilders annually, not to mention the profit which he made by selling the paintings and prints of those pupils which amounted to an additional 2,000–2,500 guilders in cash, and add to that all that he made from his own paintings.' Sandrart's account is undoubtedly tinged with envy but it does substantiate other contemporary reports which make it clear

4

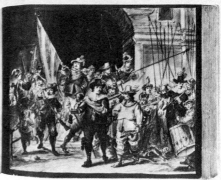

Top: *Watercolour (before 1655) copy of* The Night Watch, *from an album once owned by Captain Frans Banning Cocq. Amsterdam, Rijksmuseum.* Bottom: *Drawing of Titus and his nurse Geertge Dircx (?) (22 × 15 cm; Haarlem, Teylers Museum).*

that around 1640 Rembrandt had more students than any other painter in the Netherlands with the exception of Rubens. Some of these pupils went on to have distinguished careers working in styles quite different from that of their master. That Rembrandt's pupils went their own, often markedly independent, ways has suggested to some writers that they consciously rejected Rembrandt's approach. However, the truth seems to be that Rembrandt's method of teaching was designed to develop individual talents and in this respect he contrasted markedly with Rubens, none of whose pupils escaped his powerful influence.

The dramatic style of *The Night Watch*, with its sense of hectic movement within the picture space and its flashes of light against the dark background, is actually an anachronism within Rembrandt's work of the 1640s, for the decade sees him evolving a more restrained and intimate account of Biblical scenes. It is at this time, too, that Rembrandt's attention turns so markedly to the classicism of Italian models. A fine example of this gradual process is *Christ and the Woman taken in Adultery* (No. 231; London, National Gallery) of 1644. In some respects this is an unexpected painting for the mid-1640s, for in the composition – the small figures dwarfed by the cavernous interior of the temple – as well as in the elaboration of detail and the degree of finish, particularly in the background, it harks back to paintings of the early 1630s (for example, *The Presentation of Christ in the Temple* of 1631 [1st Vol., No. 48; The Hague, Mauritshuis]). However, the broader treatment of the foreground figures is quite consistent with the religious paintings of the 1640s. Above all, the quieter, less emotional mood of the picture is characteristic of this group of mature paintings.

Rembrandt had painted a few landscapes in the late 1630s but it was in the following decade and especially towards the end of it that he turned increasingly to landscape. The best of his landscape etchings and drawings date from these years. His house was not far from the St Anthonispoort, one of the gates of

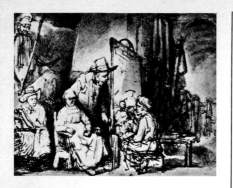

Left: *Drawing by a pupil of Rembrandt showing the artist's studio (pen and watercolour, 17.5 × 23.2 cm, c.1648; Paris, Louvre)*. Right: *Drawing by Rembrandt of his studio with a nude model (pen and watercolour, 20 × 18.9 cm, c.1650; Oxford, Ashmolean Museum)*. Below, left: *Etched self-portrait, 11.8 × 6.4 cm, 1658.*

and powerful compositions, they are variations upon a late mannerist formula rather than upon a response to nature itself.

After Saskia's death Rembrandt had taken into his household a widow, Geertge Dircx, as a nurse for his son, Titus. She soon became the artist's mistress. By 1649 she had been displaced in Rembrandt's affections by Hendrickje Stoffels, and Rembrandt found himself involved in lengthy legal wrangling with Geertge. Eventually, by none too admirable means, Rembrandt managed to have her confined in an asylum in Gouda, where she spent five years before being rescued by her friends. In happier days Geertge was probably the model for Sarah in *Sarah awaiting Tobias on their wedding night* (No. 241; Edinburgh, National Gallery of Scotland). The true subject of this painting of the late 1640s (only the first three digits of the date – 164 – are legible) was lost until recently when it was pointed out that Rembrandt took the figure of Sarah from a painting of this subject by Pieter Lastman (now in the Museum of Fine Arts, Boston). The story is from the apocryphal Book of Tobit, for which it seems Rembrandt had an especial affection as he so often represented scenes from it. Sarah had been married seven times before her wedding to Tobias, but each time her husband had been killed by the devil Asmodeus on the wedding night, before the marriage could be consummated. In Rembrandt's painting Sarah watches from the bed as Tobias burns ash of perfume and the innards of a fish, and the Angel Raphael appears, to drive away Asmodeus. The couple spent the rest of the night in prayer and the curse which had hung over Sarah was finally lifted.

Although the 1650s saw the climax of Rembrandt's financial difficulties, the artist was still in great demand, and from 1652 dates the beginning of one of his most interesting series of paintings – commissions from Don Antonio Ruffo, a Sicilian nobleman and

the city, from where it was easy to reach villages such as Diemen which stood on the banks of the River Amstel. One of the best known of Rembrandt's landscape etchings is *Six's Bridge* of 1645 which shows a view of the estate of Rembrandt's friend, Jan Six. Gersaint, the author of the first catalogue of Rembrandt's etchings, relates a story which may contain an element of truth. He tells us that Rembrandt etched this plate during a brief interval between courses at dinner with Six when a servant had been sent to fetch mustard from a nearby village. Whatever the truth of the story, it does convey something of the remarkable spontaneity apparent in the landscape etchings. They have all the freshness and immediacy of a sketch made on the spot.

Unfortunately few of Rembrandt's landscape paintings, with the notable exception of the *Winter Landscape* of 1646 (No. 251; Kassell, Gemäldegalerie), retain this quality. The majority of his landscape paintings adopt the almost monochrome palette of greens and browns which Rembrandt took from Hercules Seghers and although they are effective

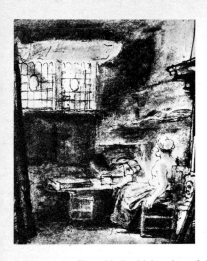

collector. Ruffo paid the high price of 500 guilders (in a later correspondence this is said to be eight times the sum an Italian painter would have received for the picture) for a painting described in the catalogue of Ruffo's collection as *Aristotele che tiene la mano sopra una statua, mezza figura al naturale*. The picture, *Aristotle contemplating the bust of Homer* (No. 278), is now in the Metropolitan Museum, New York. Ruffo was evidently pleased with the picture as in 1660 he asked the Italian painter Guercino to make a companion to it and to do it 'in the early vigorous manner' (that is, his Caravaggesque manner) so that it might better harmonize with the Rembrandt. Guercino's reply of June 1660 survives and is fascinating to read: Guercino knew Rembrandt's etchings and admired them very much. He considered the Dutch master a true virtuoso. He asked for and received a drawn copy of Rembrandt's painting but his question as to who (or what) was represented was apparently never answered. Guercino was forced to guess the subject and assuming, he says, that Rembrandt's picture represented a physiognomist he had painted a cosmographer as a pendant. (Ruffo seems also to have been in some doubt about the true subject of the picture, which suggests that this unusual subject was Rembrandt's own.)

It is curious that Ruffo waited six years before ordering a pendant to the Aristotle, and even more so that he turned to Guercino. Although there is no direct evidence, it may be that he approached Rembrandt and then sought out Guercino when his patience wore thin. Houbraken in his account of Rembrandt mentions that the artist's patrons had to wait a long time for their pictures, and that to obtain anything from him they had – in the words of a proverb – 'to beg him and still add money'. We know of several instances of delay in delivering paintings – two of the Passion series, half-finished in 1636, were not completed until 1639. The painting of *Juno* (No. 394; Los Angeles, Armand Hammer Collection) was very reluctantly completed for Harmen Becker. Rembrandt sent two further paintings to Ruffo shortly after Guercino had finished his *Cosmographer*, and he intended them as companion pieces to the *Aristotle*. They arrived in Ruffo's home town of Messina late in 1661 and in the shipping bill were identified as portraits of Alexander the Great and Homer. A year later Ruffo, who we know had been greatly pleased when the pictures first arrived, complained to the artist that the Alexander was unprofessionally made up of four pieces of canvas and that the seams were disturbingly visible. He suspected, he wrote, that Rembrandt had simply taken a head painted earlier and enlarged it into a half-length figure by adding pieces of canvas. Yet Ruffo said he would keep the picture if Rembrandt reduced the price by half (which, he claimed, was still more than Italian artists would get). Otherwise, Rembrandt ought to paint a replacement. There was no argument about the *Homer* which Rembrandt had sent unfinished. Ruffo agreed to accept it if it were completed. The *Homer* was returned to Amsterdam and shipped back to Sicily in 1664. About Ruffo's criticisms of the *Alexander* Rembrandt wrote (the letter is lost and only an Italian transcription is preserved) curtly that there were obviously no good connoisseurs in Messina, and that the seams would not show if the picture were hung in the right light. He would paint a replacement if Ruffo was willing to pay 600 guilders (100 more than for the first) and return the first picture at his own expense and risk. The outcome is not known.

The *Homer* is thought to be the painting now in the Mauritshuis at The Hague (No.

387), although it is now in a fragmentary state. About the identity of the *Alexander* there has been much discussion. There are two candidates, paintings in Glasgow (No. 354) and Lisbon (No. 353). The most likely explanation seems to be that the Glasgow painting is the first, rejected version, which may have been a reworked studio picture (even possibly a portrait of Titus) as Ruffo suspected, and the Lisbon picture the second version. The case for this identification is strengthened by the rarity of these images elsewhere in Rembrandt's work.

As well as being an admirer of Rembrandt's paintings, Ruffo collected his etchings: in 1669, the year of Rembrandt's death, the Sicilian nobleman ordered and received 189 of them. Other Italian patrons of Rembrandt included the Medici. When Cosimo de' Medici later Grand Duke Cosimo III of Tuscany was visiting Holland in 1667–8 he visited Rembrandt's studio. His guide Pieter Blaeu clearly considered it to be one of the sights of the city. On this occasion Cosimo did not buy, but he may well have bought one of the *Self-Portraits* now in the Uffizi (Florence) during this trip. The other *Self-Portrait* was bought by Cardinal Leopold de' Medici who began the famous Medici collection of artists' portraits soon after Rembrandt's

Poster for the auction sale of Rembrandt's possessions; Amsterdam, Rembrandtshuis.

death. A third painting by the Dutch master, an *Old Man with Folded Hands*, was bought during the artist's lifetime.

These contacts with Italian patrons are worth stressing because they are little known and they make it quite clear that Rembrandt's work was highly esteemed outside Holland and was very much in demand in the last two decades of his life, when he is traditionally said to have been no longer fashionable or successful.

The 1650s mark a heroic period in Dutch painting – Jacob van Ruisdael's greatest landscapes, Hals's finest portraits, Koninck's landscapes, Fabritius's rare masterpieces, the early works of Vermeer and the late, almost classical phase of Jan van Goyen. Many other lesser-known painters – Bartholomeus van der Helst, Paulus Potter, Gerard Terborch, Cesar van Everdingen among them – produced their finest work.

For Rembrandt, too, it was a heroic decade in his art. One example from many is the *Jacob blessing the sons of Joseph* (No. 310; Kassel, Gemäldegalerie) of 1656. It is one of the most moving and tender of all his scenes from the Bible. The moment which Rembrandt represented is described in Genesis, 48: 17–19. In the painting Jacob's right hand rests on the head of the larger, fair-haired child from whom contemporary belief traced Gentile ancestry. The elder boy, Manasseh, who is small and dark, is blessed with the left hand. The submissive gesture of Ephraim's crossed hands, Joseph's tender regard for his father, Manasseh's intense gaze towards his brother are all painted in strong, broad strokes. The unusual presence of Asenath, Joseph's wife, also in an attitude of submission, strengthens and balances the composition.

Among a number of fine portraits of the 1650s is that of Rembrandt's friend Jan Six (No. 285; Amsterdam, Six Foundation), painted in 1654 as we know from a poem Six wrote to celebrate the portrait. Six, the son of a wealthy Amsterdam textile merchant, travelled to Italy after his education at Leiden University and on his return became something of a dilettante. The friend and patron of poets and painters, he wrote his own poetry and plays (Rembrandt etched illustrations for his play *Medea*) and formed a large collection of paintings, drawings and antique statuary.

Not until in 1652, having taken little interest in the family business, did he begin a career, as a city magistrate. It is in this sober guise that he appears in this magnificent portrait which has remained in the collection of the Six family until this day. Rembrandt's friendship with Six was eventually soured by quarrels about money. Another superb portrait of this remarkably creative period was the *Nicolaes Bruyningh* (No. 276; Kassel, Gemäldegalerie) of 1652. Rembrandt had experimented in a series of painted and etched portraits with the depiction of seated figures but in none does he manage by the sitter's pose to convey better his humanity than in this portrait. Bruyningh leans forward in his chair as if about to engage the spectator in lively conversation.

If the 1650s was a heroic decade in Rembrandt's art, it was hardly a heroic decade in his life. By 1653 he had paid only a half of the 13,000 guilders he owed for his house in the Sint Anthonisbreestraat and the vendor, Christopher Thijs, called in the outstanding amount. Rembrandt raised the money by borrowing from various leading Amsterdammers (one, Cornelis Witsen, had just become burgomaster; another was Jan Six). However, this was only a temporary respite and in 1656 Rembrandt had to apply for a *cessio bonorum* at the High Court in The Hague. The reasons he gave were 'losses in trade, including overseas trade'. This could have been a euphemism or Rembrandt may have invested and lost in trade ventures. This was the time of the First Anglo-Dutch War (1652–4) and the consequent economic recession. To this unfortunate event in Rembrandt's life we owe a document of great importance – the inventory of Rembrandt's possessions in his house on the Sint Anthonisbreestraat which had to be sold. An impressive collection included ancient relics and art objects from Asia, weapons, musical instruments and, of course, paintings. There were Italian paintings (Giorgione, Palma Vecchio, Lelio Orsi, Raphael and the Carracci are among the artists to whom the paintings were, perhaps over-enthusiastically, attributed) as well as those Dutch artists (Seghers, Lievens, Brouwer and Lastman) whom Rembrandt held in the highest esteem. There were also those of his own works which he had retained, including that mysterious political

allegory, *The Concord of the State* (No. 214; Rotterdam, Museum Boymans-van Beuningen). The collection of drawings and etchings was especially large, but unfortunately it is not described in detail. The first auction of the collection lasted for three weeks. Then came the house itself, and the etchings and drawings which fetched far too little, perhaps as the result of poor publicity or the general recession. Rembrandt did not have to leave the house until December 1660 when with Hendrickje and Titus he took a house on the Rozengracht. Three days earlier Rembrandt, Titus and Hendrickje (who, being illiterate, signed with a cross) confirmed an earlier arrangement under which they were to continue trading in Rembrandt's paintings, drawings and etchings 'so long as the above-mentioned Rembrandt van Rijn shall live, and for six years after his death'. This clause was followed by special arrangements among the three. The contract was a complicated legal manoeuvre to protect Rembrandt from his creditors and enable him to continue working. The Amsterdam guild had a provision that a painter who had gone bankrupt could not continue to practise his profession.

There can be no doubt, however, that despite his financial problems, Rembrandt remained one of Amsterdam's leading pain-

The Westerkerk at Amsterdam. Engraving by F. de Wit, 13 × 13 cm, c.1650; London, British Museum. Rembrandt was buried here on 8 October 1669.

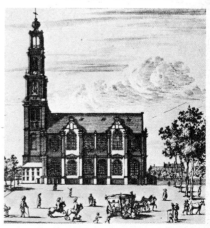

ters. In a poem by Jan Vos, for example, celebrating the re-establishment of the Guild of St Luke, Rembrandt is named among the city's greatest painters. He received a succession of important commissions during the last decade of his life: there was, for example, the group portrait of the *Staalmeesters* (The Sampling Officials of the Drapers' Guild) painted in 1662 (No. 383; Amsterdam, Rijksmuseum); the huge equestrian portrait of Frederik Rihel of 1663 (No. 390; London, National Gallery); and the *Conspiracy of Julius Civilis* (No. 356; Stockholm, Nationalmuseum) painted for Amsterdam's new Town Hall. The commission for the painted decoration of Jacob van Campen's magnificent Town Hall, which was inaugurated in 1655, had gone to Rembrandt's pupil, Govaert Flinck. When Flinck died in 1660, commissions for individual paintings went to a number of different artists including Rembrandt, Lievens and Jacob Jordaens. The theme of the decoration was the Batavian revolt against the Romans, which contemporaries saw as a prototype of the struggle of the Dutch against the Spanish. Rembrandt was commissioned to paint a nocturnal scene, the swearing of the oath to resist the Romans. The canvas was in place in 1662 but soon after, probably in the following year, it was taken down and replaced by a canvas by Jurriaen Ovens who seems simply to have completed Flinck's sketch. The reason for the rejection of Rembrandt's painting is not known. It may be that his depiction of Julius Civilis (identified with William the Silent) as a one-eyed barbarian chieftain, in which he followed Tacitus, the classical source, was not decorous enough for the city fathers of Amsterdam.

A study of the *Julius Civilis* (which has been cut down, perhaps by the artist himself) displays how fundamentally Rembrandt's style had changed from the small-scale, highly finished history paintings of the Leiden years which had been so admired by Huygens. In the early pictures Rembrandt had conveyed the narrative by the precise characterization of each figure. They register their reactions to the events taking place by gestures and facial expressions which are often exaggerated. The *Judas and the Thirty Pieces of Silver* (1st vol., No. 25), which Huygens singled out for praise, is an example of this narrative technique. However, after his brief flirtation with Caravaggesque effects in the late 1630s, Rembrandt achieved a far more restrained and convincing approach to history painting. He came to realize that greater narrative power could be achieved by concentration upon key figures rather than the careful depiction of the reactions of a mass of bystanders. This concentration upon the essence of the drama is central to Rembrandt's mature history paintings. He cuts down the number of participants in any one scene and increases their scale in proportion to the total canvas or panel size. This has taken place in, for example, the *Jacob blessing the sons of Joseph* (No. 310) of 1656 but if we look at the *Return of the Prodigal Son* (No. 405; Leningrad, Hermitage) of a decade later, the process has gone even further with the two principal figures, the father and son, given a monumentality which is Rembrandt's greatest achievement in his religious paintings. Father and son are a single whole, and the sense of pure compassion is almost unbearably moving. The reconciliation is not bound to a particular time or place, for the background setting is scarcely suggested by the artist. This gain in narrative strength through a concentration upon a few monumental figures coincides with a broader application of paint: figures are suggested by bold outlines rather than carefully delineated, and there is a new interest in the surface texture of the painted canvas. Late paintings such as *The Jewish Bride* (No. 406; Amsterdam, Rijksmuseum) of 1667 or 1668 have a quite unprecedented richness of surface colour and detail.

The last years of Rembrandt's life saw a series of personal tragedies. Hendrickje, who had stood beside him loyally during the years of his bankruptcy and the sale of his possessions, died in 1663, and in 1668 his son Titus, who had married in the previous year, also died. The self-portraits of these years show a face which, although troubled, possesses great strength and resilience. Rembrandt himself died in 1669 and was buried alongside Saskia and Titus in the Westerkerk.

Catalogue of the Paintings

All measurements are in centimetres.
s.d. = signed and dated

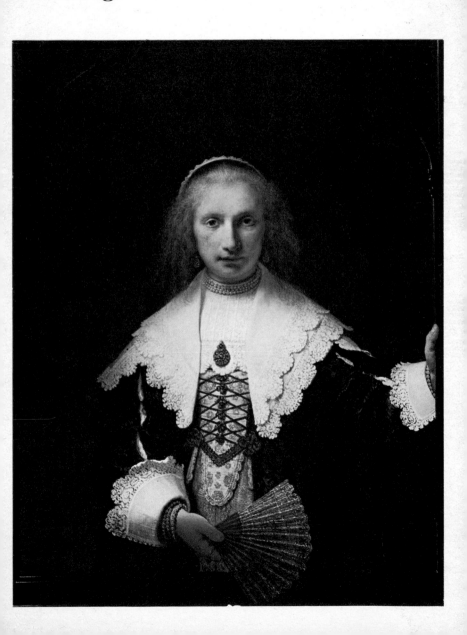

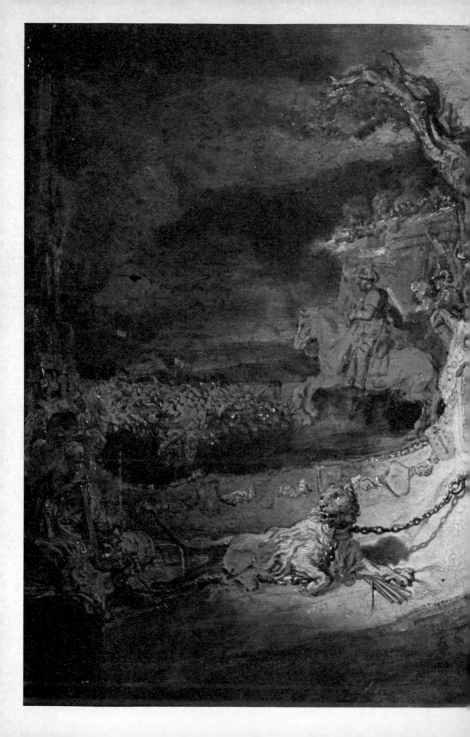

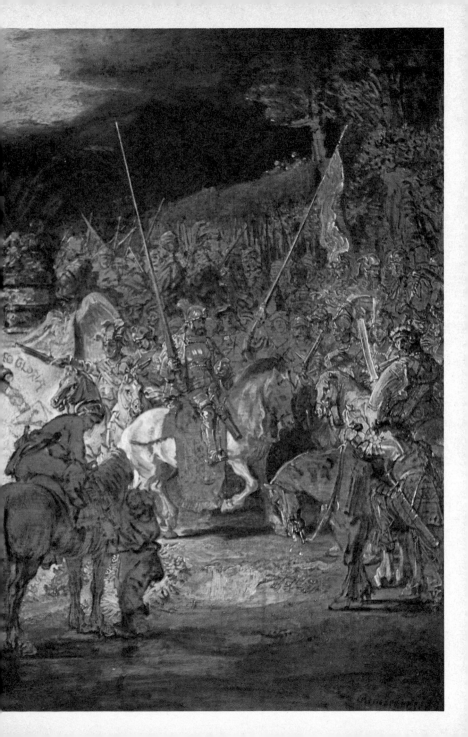

Portrait of Agatha Bas
(No. 213) (p. 11)

Agatha Bas and her husband Nicolaes van Bambeeck (whose portrait is pendant to this one) lived in the Sint Anthonisbreestraat where Rembrandt and Saskia had bought a house in 1639. The contact was even closer, as Bambeeck had lent money (as had Rembrandt) to Saskia's cousin to finance his business. This personal link between artist and sitters is reflected in the enormous care which Rembrandt lavished on these superb portraits.

The Concord of the State
(No. 214) (pp. 12–13)

There has been much discussion about the meaning and the function of this mysterious grisaille. It is listed in Rembrandt's inventory as 'De Eendragt van 't Lant' (The Concord of the State), but the precise meaning of the political allegory is unclear. A prominent place is given to the coat of arms of the city of Amsterdam. It seems most likely that it was a design – like other grisailles – for an etching, but it could also have been a sketch for a larger painting.

201 The Departure of the Shunamite Wife
Oil on panel/39 × 53/s.d.1640
London, Victoria and Albert Museum

202 The Visitation
Oil on panel/57.5 × 48.5/ s.d.1640
Detroit, Institute of Arts

203 The Holy Family
Oil on panel/41 × 34/s.d.1640
Paris, Louvre

204 The Entombment of Christ
Oil on panel/32.2 × 40.5/ c.1640
Glasgow, Hunterian Museum and University Art Collection

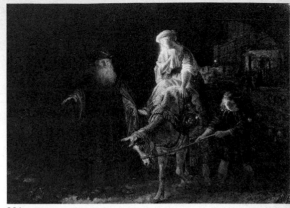

201

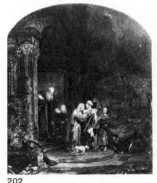

202

203

204

205

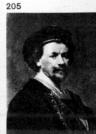

14

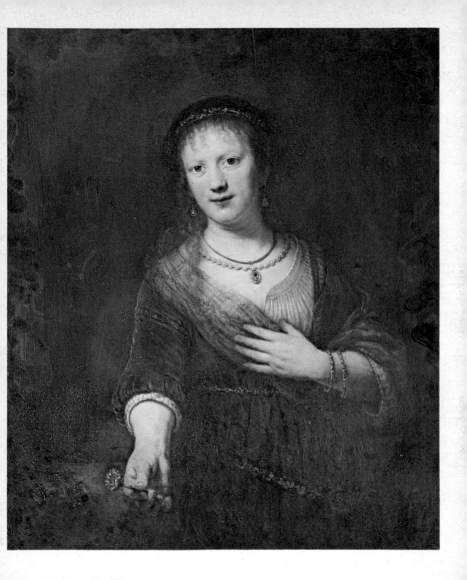

Saskia with a Flower (*No. 217*)
This portrait of Saskia is especially moving when we realize that it was painted in 1641, the year before her death. She had been weakened by continual pregnancy and never recovered from the birth in 1641 of her son Titus. There is a directness in her gesture and a tenderness in the representation of her features which makes this a far more compelling image than any of the earlier portraits of her.

205 Self-Portrait
Oil on panel 62.5 × 50/s./
*c.*1640
Pasadena, California, Norton
Simon Museum of Art

15

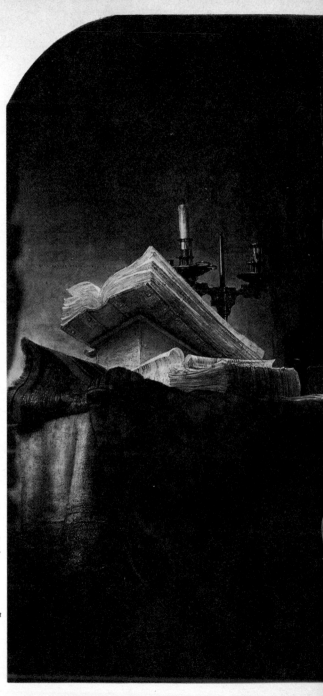

Cornelis Claesz. Anslo in
conversation with a Woman
(No. 218)
The great Mennonite preacher
first sat to Rembrandt in 1640.
The artist used the drawings
he made in the first place for
an etched portrait of 1641.
This painting of the preacher,
open-mouthed and
gesticulating, expounding from
the Bible to an attentive
member of his congregation,
seems to be a conscious
response to the challenge from
the poet Joost van den Vondel
to paint Cornelis's voice.

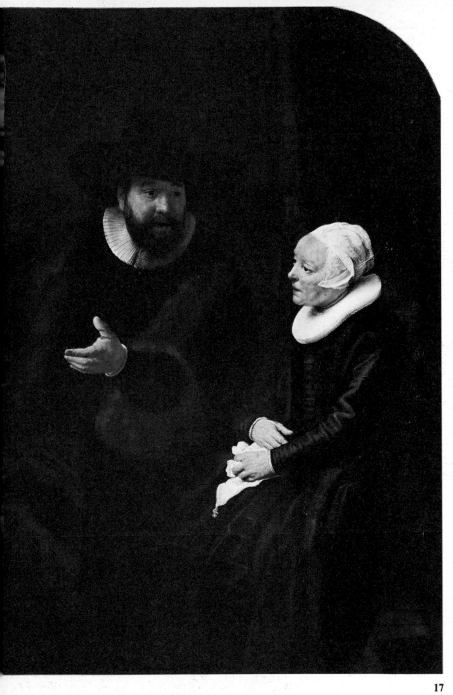

206 Self-Portrait
Oil on canvas/94 × 74.5/
c.1640
Probably a studio copy of an
original.
Ottawa, National Gallery
of Canada

207 Self-Portrait
Oil on panel/64 × 49/c.1640
London, Wallace Collection

208 Self-Portrait
Oil on canvas/100 × 80/
s.d.1640
London, National Gallery

209 Herman Doomer
Oil on panel/75 × 55/s.d.1640
Pendant to No. 210.
New York, Metropolitan
Museum of Art

**210 Baartjen Martens, wife of
Herman Doomer**
Oil on panel/76 × 56/s./c.1640
Pendant to No. 209 (dated
1640).
Leningrad, Hermitage

211 The Slaughtered Ox
Oil on panel/73.5 × 52/
c.1637–40
Glasgow, Art Gallery and
Museum

212 Nicolaes van Bambeeck
Oil on canvas/105,5 × 84/
s.d. 1641
Pendant to No. 213.
Brussels, Musée Royal des
Beaux-Arts

**213 Agatha Bas, wife of
Nicolaes van Bambeeck**
Oil on canvas/105.5 × 84/
s.d.1641
Pendant to No. 212.
London, Buckingham Palace,
Royal Collection

214 The Concord of the State
Grisaille – oil on panel/
74.6 × 101/s.d.1641
Rotterdam, Boymans-van
Beuningen Museum

215 A Young Girl
Oil on panel/104 × 76/
s.d.1641
Pendant to No. 216.
Present location unknown

216 A Scholar at his desk
Oil on panel/104 × 76/
s.d.1641
Pendant to No. 215.
Present location unknown

18

207

206

209

208

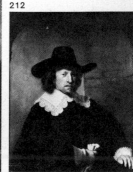
210

211

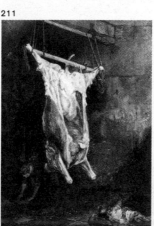

212

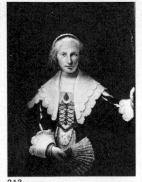

213

215

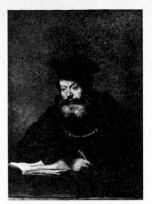

216

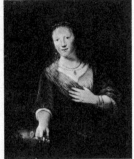

217

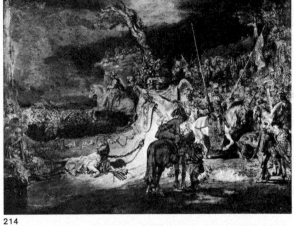

214

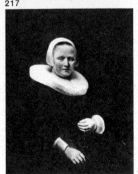

219

218

220

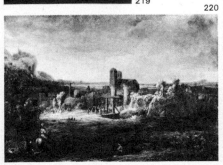

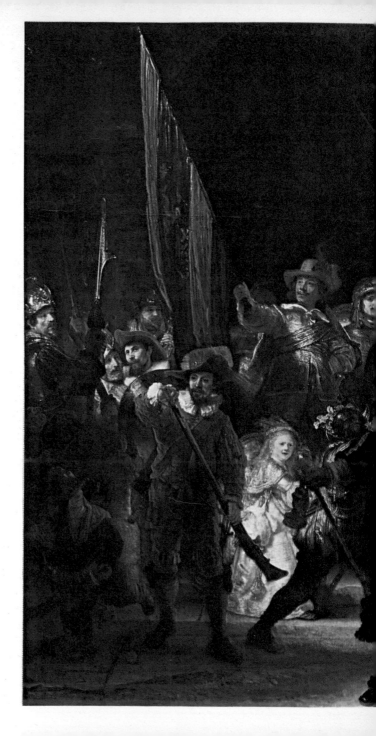

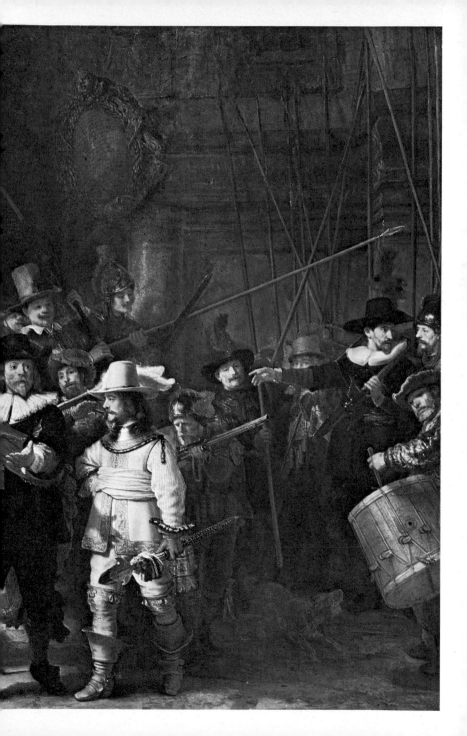

'*The Night Watch*' (No. 223)
(*pp. 20–21*)
Militia companies were usually portrayed standing in stiff rows or gathered around a dinner table, and it was entirely novel to show them marching out. It is this dynamic composition which makes the painting so effective.

***Christ and the Woman taken in Adultery** (detail) (No. 231)*
The broad treatment and the concentration upon fewer figures to evoke the drama represents the way forward to the later religious masterpieces.

217 Saskia with a Flower
Oil on panel/98.5 × 82.5/
s.d.1641
Dresden, Gemäldegalerie

218 Cornelis Claesz. Anslo in conversation with a Woman
Oil on canvas/176 × 210/
s.d.1641
Berlin-Dahlem,
Gemäldegalerie

219 Portrait of a Woman (Anna Wijmer?)
Oil on panel/96 × 80/s.d.1641
The attribution has been doubted.
Amsterdam, Six Foundation

220 Landscape with a Church
Oil on panel/42 × 60/c.1640–2
Madrid, Collection of the Duke of Berwick and Alba

221 Landscape with a Coach
Oil on panel/46 × 64/c.1640–2
London, Wallace Collection

222 The Reconciliation of David and Absalom
Oil on panel/73 × 61.5/
s.d.1642
Leningrad, Hermitage

223 'The Night Watch' (The Militia Company of Captain Frans Banning Cocq)
Oil on canvas/359 × 438/
s.d.1642
Cut down, especially on the left and at the top.
Rijksmuseum, Amsterdam

221

224

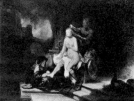

222

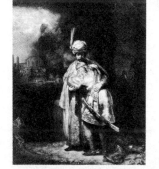

225

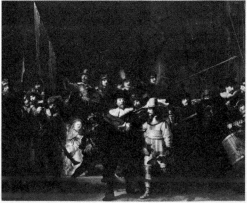

223

224 Bathsheba seen by King David
Oil on panel/57 × 76/s.d.1643
New York, Metropolitan
Museum of Art

225 Biblical Figure
Oil on panel/70.5 × 53.5/
s.d.1643
Budapest, Museum of Fine
Arts

226 Self-Portrait
Oil on panel/71 × 57/
Perhaps a copy of a lost
original.
Pendant to No. 227.
Boston, Museum of Fine Arts

227 Saskia (posthumous portrait)
Oil on panel/72 × 59/s.d.1643
Pendant to No. 226.
Berlin-Dahlem,
Gemäldegalerie

228 An Old Man in Rich Costume
Oil on panel/71 × 58/s.d.1643
Woburn Abbey, Collection of
the Duke of Bedford

229 Old Man with a Beret
Oil on panel/51 × 42/c.1643
Leningrad, Hermitage

230 Landscape with a Castle
Oil on panel/44.5 × 70/c.1643
Paris, Louvre

231 Christ and the Woman taken in Adultery
Oil on panel/84 × 65.5/
s.d.1644
London, National Gallery

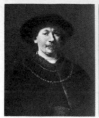 226 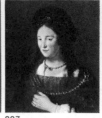 227 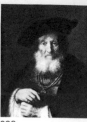 228

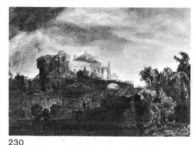 230 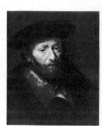 229

Young Woman leaning on a windowsill (No. 239)
Studies of young girls are unusual in Rembrandt's work, as the models he usually chose for such character studies were elderly men. This delightful painting – half way between genre scene and portrait – has long been greatly admired in England and was copied by Sir Joshua Reynolds.

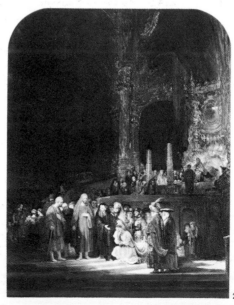 231

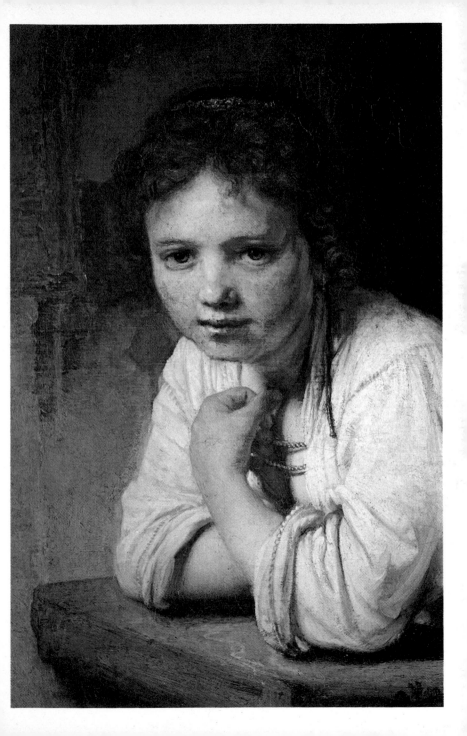

232 Young Man holding a sword
Oil on canvas/103 × 86.5/
s.d.1644
The attribution has been doubted.
Brunswick (Maine), Bowdoin College Museum of Art

233 Man holding a glove
Oil on panel/80.5 × 67.5/
s.d.164(.)/c.1644
New York, Metropolitan Museum of Art

234 Man standing in a doorway
Oil on canvas/102.5 × 75/
s.d.164(.)/c.1644
Formerly Tisbury, Wiltshire, Collection of Lord Margadale

235 Woman seated in an armchair
Oil on canvas/124.5 × 100.5/
s.d.1644
Toronto, Art Gallery of Ontario

236 Anna accused by Tobit of stealing the kid
Oil on panel/20 × 27/s.d.1645
Berlin-Dahlem, Gemäldegalerie

232

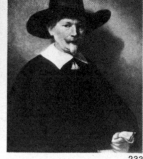
233

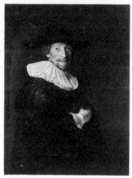
234

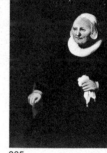
235

Sarah awaiting Tobias on their wedding night (No. 241)
The true subject of this painting has only recently been discovered by comparison with a painting of the same subject by Rembrandt's master, Pieter Lastman. The story, from the Apocrypha, tells how Sarah had been married seven times before her wedding to Tobias, but each time her husband had been killed by the devil Asmodeus on the wedding night. Sarah watches from the bed as Tobias burns ash of perfume and the innards of a fish, and the angel Raphael appears to drive away Asmodeus. The couple spend the rest of the night in prayer and the curse which had hung over Sarah is finally lifted.

236

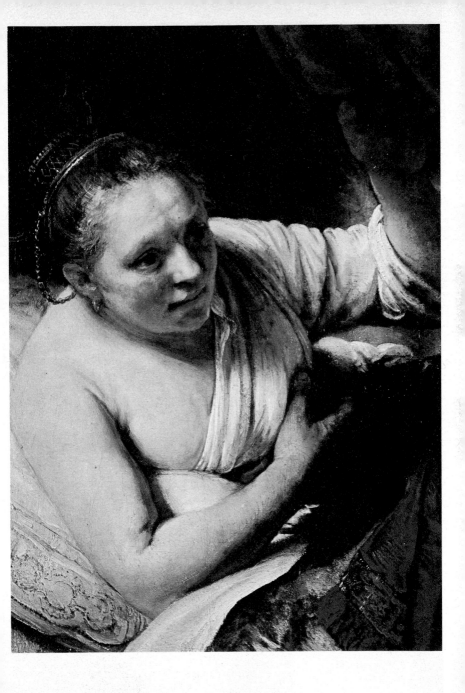

237 Joseph's Dream in the Stable at Bethlehem
Oil on panel/20 × 27/s.d.1645
Berlin-Dahlem,
Gemäldegalerie

238 The Holy Family with Angels
Oil on canvas/117 × 91/
s.d.1645
Leningrad, Hermitage

239 Young Woman leaning on a windowsill
Oil on canvas/77.5 × 62.5/
s.d.1645
London, Dulwich College
Gallery

240 Portrait of a Boy (Titus?)
Oil on canvas/65 × 56/c.1645
Unfinished.
Pasadena, Norton Simon
Museum of Art

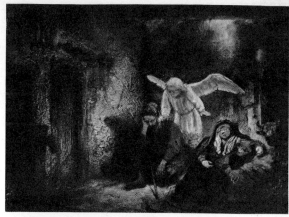
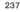

237

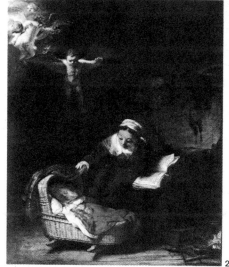

238

Winter Landscape (No. 251) (pp. 30–31)
Rembrandt painted this sparkling winter landscape quickly and fluently. As can be seen from an inspection of the surface, the signature and date were added when the paint was still wet. In all his other painted landscapes Rembrandt adopts the near-monochrome palette of Hercules Seghers, but the brighter palette and more well-defined forms make it seem that here he was experimenting with the landscape style of another Haarlem painter, Esaias van de Velde.

239

240

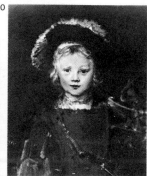

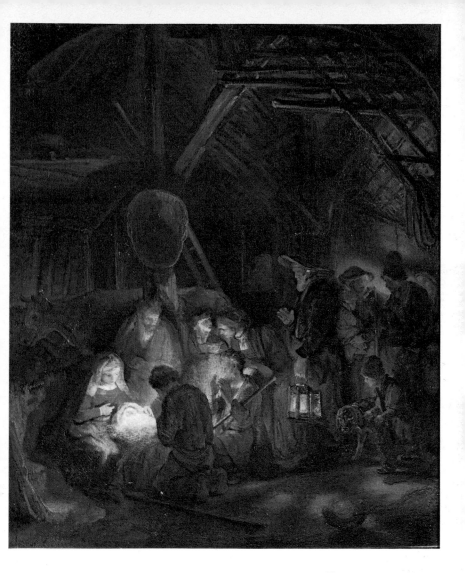

The Adoration of the Shepherds (*No. 250*)
Unlike other Dutch painters of the period, Rembrandt rarely painted replicas of his work. This painting, however, is a smaller version of one of the Passion series painted for Prince Frederik Henry. The position of some of the figures has been altered, but the composition remains in all its essentials unchanged.

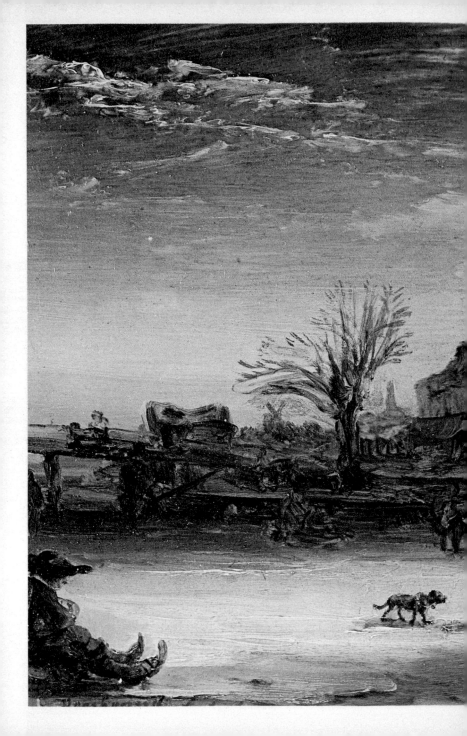

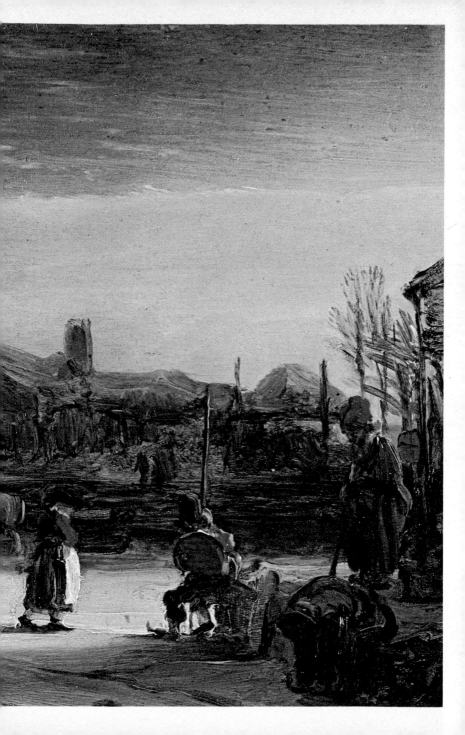

241 Sarah awaiting Tobias on their wedding night
Oil on canvas/81 × 67/
s.d.164(last digit illegible)/
c.1645
Edinburgh, National Gallery of Scotland

242 Old Man with a Stick
Oil on canvas/128.2 × 112.1/
s.d.1645
Lisbon, Museu Calouste Gulbenkian

243 Young Woman at a Door
Oil on canvas/100 × 84/
s.d.1645
Chicago, Art Institute

244 Clement de Jonghe (?)
Oil on canvas/92.5 × 73.5/s./
c.1645
Buscot Park, Berkshire, Faringdon Collection

245 Old Man in a Fur-lined Coat
Oil on canvas/110 × 82/
s.d.1645
Berlin-Dahlem, Gemäldegalerie

246 Self-Portrait
Oil on panel/67.5 × 57.5/
s.d.164(.)/c.1645
Windsor Castle, Royal Collection

Ephraim Bueno (No. 261)
The sitter, Dr Ephraim Bueno (1594–1665), was a well-known member of the Jewish community in Amsterdam, with which Rembrandt had a number of close links. He was a physician and a publisher of Jewish books. This is an oil sketch for a portrait etching of 1647.

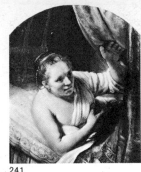
241

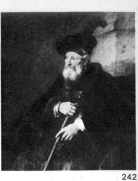
242

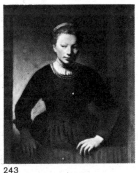
243

244

245

246

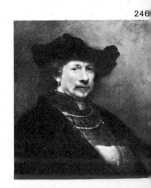

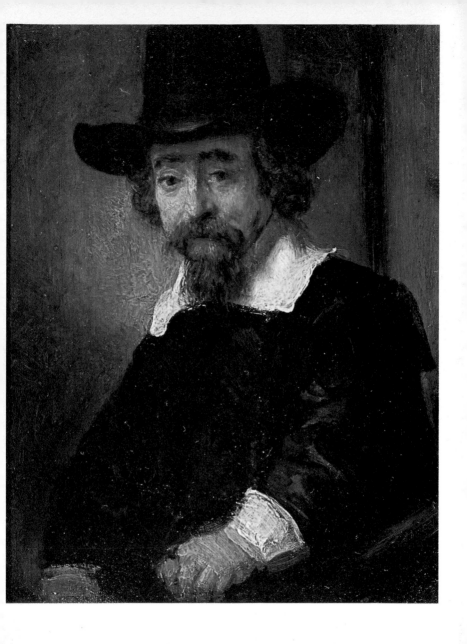

247 The Holy Family (with painted frame and curtain)
Oil on panel/46.5 × 68.8/
s.d.1646
Kassel, Gemäldegalerie

248 Abraham serving the three angels
Oil on panel/16 × 21/s.d.1646
New York, Collection of Mrs
C. von Pannwitz

249 The Adoration of the Shepherds
Oil on canvas/97 × 71.3/
s.d.1646
Munich, Alte Pinakothek

250 The Adoration of the Shepherds
Oil on canvas/65.5 × 55/
s.d.1646
London, National Gallery

251 Winter Landscape
Oil on panel/17 × 23/s.d.1646
Kassel, Gemäldegalerie

The Supper at Emmaus (No. 263)
A comparison of this painting of 1648 with Rembrandt's treatment of the same subject almost twenty years before (1st Vol., No. 19), shows how his art had developed in the intervening years. For both paintings he chose the moment when Christ revealed himself to the Apostles, but whereas the earlier painting is highly dramatic in lighting and in gesture, the reaction is far more restrained in this picture and consequently far more moving.

247

248

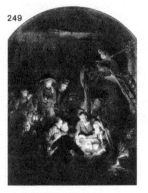
249

250

251

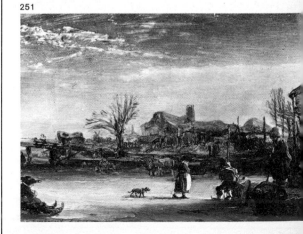

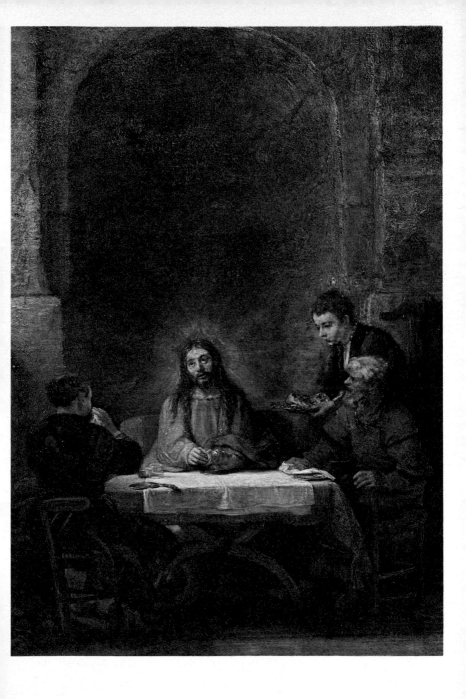

252 Rest on the Flight to Egypt
Oil on panel/34 × 48/s.d.1647
Dublin, National Gallery of Ireland

253 Susannah and the Elders
Oil on panel/76 × 91/s.d.1647
Berlin-Dahlem, Gemäldegalerie

254 Old Man in a Fur Cap
Oil on panel/25.1 × 22.5/ s.d.1647
Rotterdam, Museum Boymans-van Beuningen

255 Head of Christ
Oil on panel/25.5 × 21/c.1647
The Hague, Bredius Museum

256 Head of Christ
Oil on panel/25.5 × 20/c.1647
Formerly Amsterdam, P. de Boer

257 Head of Christ
Oil on panel/25.5 × 23/c.1647
Detroit, Institute of Arts

Portrait of Nicolaes Bruyningh (detail) (No. 276)
In this remarkable painting the liveliness and enthusiasm of the sitter have clearly communicated themselves to the artist. The result is one of the finest of all Rembrandt's male portraits. He was experimenting at this time with seated portraits, and that of Bruyningh, who leans, or so it seems, out of his chair towards the spectator, is the culmination of this group.

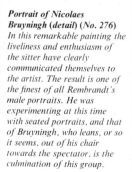

252

253

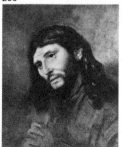

254

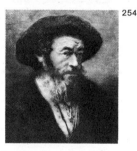

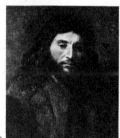

255

256

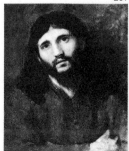

257

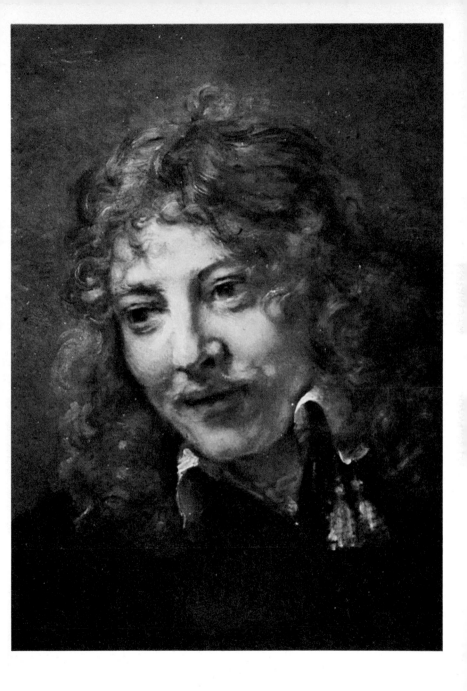

258 Head of Christ
Oil on canvas/47.5 × 37/
c.1647
Cut down.
New York, Metropolitan
Museum of Art

259 A Young Jew
Oil on panel/24.5 × 20.5/
c.1647
Berlin-Dahlem,
Gemäldegalerie

260 Self-Portrait
Oil on panel/69 × 56/c.1645–8
Karlsruhe, Staatliche
Kunsthalle

261 Ephraim Bueno
Oil on panel/19 × 15/c.1647
Amsterdam, Rijksmuseum

**262 An Old Woman with a
Book**
Oil on canvas/108 × 90/
s.d.164(7?)
Washington, National
Gallery of Art

263 The Supper at Emmaus
Oil on panel/68 × 65/s.d.1648
Paris, Louvre

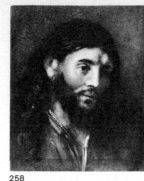

258

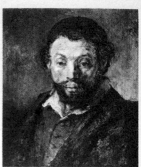

259

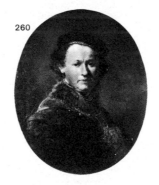

260

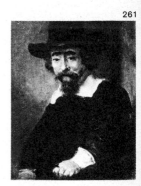

261

*Aristotle contemplating the
bust of Homer (detail)*
(No. 278)
*This picture was painted by
Rembrandt for Don Antonio
Ruffo who commissioned the
Italian painter Guercino to
paint a companion to it.
Guercino, who had been sent a
drawing of the* ARISTOTLE, *was
unclear about the exact subject
and, believing that it
represented a physiognomist,
painted a cosmographer as a
pendant.*

262

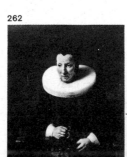

263

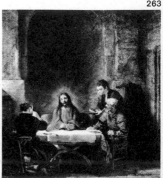

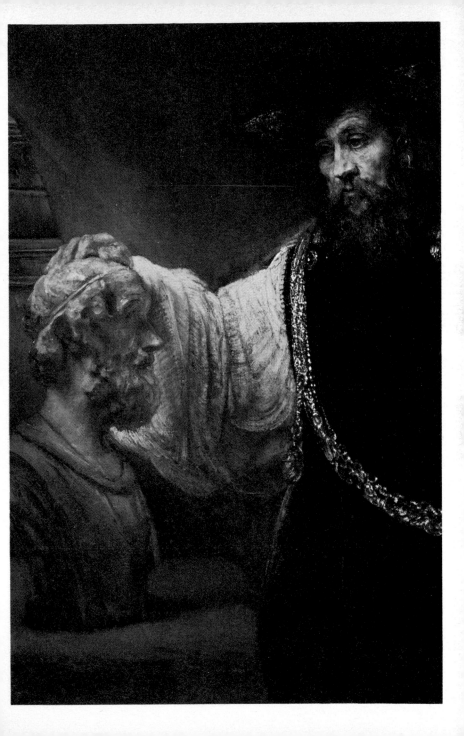

264 The Supper at Emmaus
Oil on canvas/89.5 × 111.5/
s.d.1648
Copenhagen, Royal Museum
of Fine Arts ·

**265 Anna in the Temple at
Jerusalem**
Oil on panel/40.5 × 31.5/
s.d.16(50?)
The work of a pupil
retouched by Rembrandt.
Edinburgh, National Gallery
of Scotland (Sutherland loan)

**266 A Man leaning on a
windowsill**
Oil on canvas/82 × 68.5/
s.d.1650
The attribution is doubtful.
Cincinnati, Taft Museum

267 A Franciscan Monk
Oil on canvas/89 × 66.5/
s.d.165(.)/c.1650
London, National Gallery

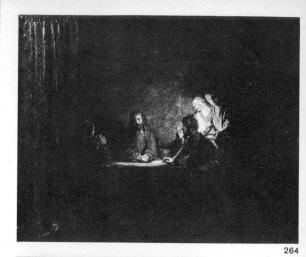

264

265

266

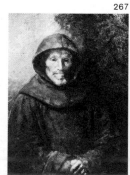

267

Hendrickje as Flora (No. 281)
Hendrickje Stoffels is first
mentioned as a member of
Rembrandt's household in
1649, and from then until her
death in 1662 she was the
artist's constant companion.
There is no documented
portrait of her, as there is of
Saskia, but there are a number
of paintings representing the
same model from the time
when she lived with the
painter. The recurrence of the
model and the affection with
which she is painted point to
her being Hendrickje.

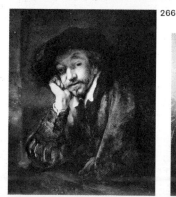

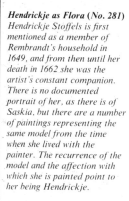

40

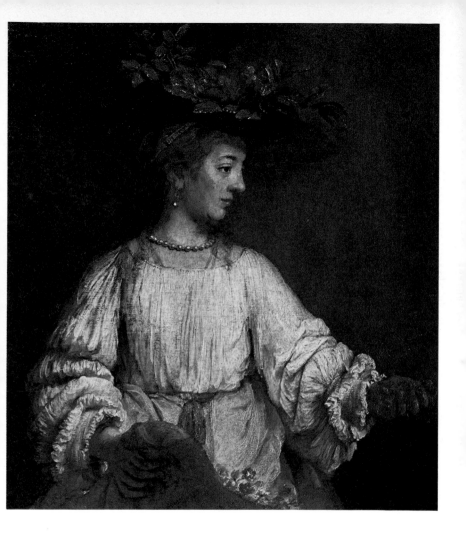

268 Portrait of a Man
Oil on canvas/80 × 67.1/
s.d.1650
The Hague, Mauritshuis

**269 The Risen Christ
appearing to Mary Magdalen**
Oil on canvas/65 × 79/
s.d.165(1?)
Brunswick, Herzog Anton
Ulrich Museum

270 King David
Oil on panel/30.2 × 26/
s.d.1651
New York, Collection of Mr
Louis Kaplan

**271 Old Man in an Armchair
(The Patriarch Jacob?)**
Oil on canvas 51 × 37/c.1651
Berlin-Dahlem,
Gemäldegalerie

272 Young Girl at a Window
Oil on canvas/78 × 63/
s.d.1651
Stockholm, Nationalmuseum

268

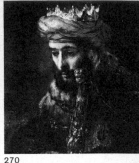

270

269

Bathsheba (No. 296)
*While her maid dries her feet
after her bath, Bathsheba
meditates on the implications
of the letter from King David
which she holds in her right
hand. She seems to sense that
the consequence of the King's
passion will be the death of her
husband Uzziah. It is likely
that the model for Bathsheba
was Hendrickje Stoffels.
Although at present
discoloured by a heavy
varnish, the painting is one of
the greatest of all Rembrandt's
many religious pictures.*

271

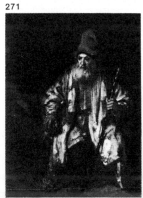

272

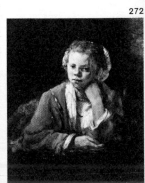

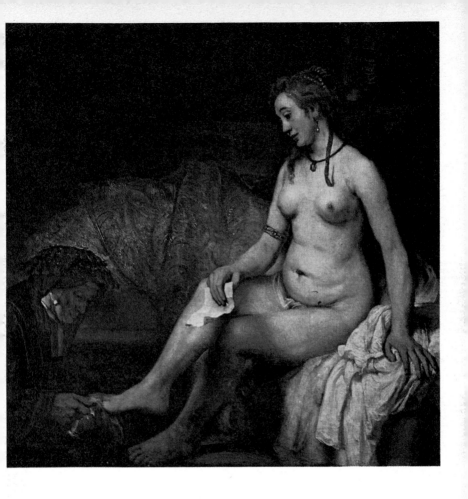

273 An Old Man in Rich Costume
Oil on canvas/79 × 76/
s.d.1651
Chatsworth, Collection of the Duke of Devonshire

274 An Old Man in a Linen Headband
Oil on canvas/77 × 66/
s.d.1651
Wanas, Sweden, Collection of Count Wachtmeister

275 An Old Man in an Armchair
Oil on canvas/111 × 88/
s.d.1652
London, National Gallery

276 Nicolaes Bruyningh
Oil on canvas/107.5 × 91.5/
s.d.1652
Kassel, Gemäldegalerie

277 Self-Portrait
Oil on canvas/112 × 81.5/
s.d.1652
Vienna, Kunsthistorisches Museum

278 Aristotle contemplating the bust of Homer
Oil on canvas/143.5 × 136.5/
s.d.1653
New York, Metropolitan Museum of Art

273

274

275

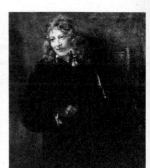

276

277

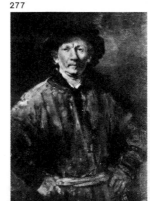

278

***Joseph accused by Potiphar's wife* (detail) (*No. 301*)**
This composition is a rare instance of Rembrandt repeating himself: there is a virtual replica of the painting in the Gemäldegalerie in West Berlin. It has been suggested that this version is a copy by a student, which was then retouched by Rembrandt and signed by him, but the quality of the two paintings seems equal and there is no reason to suppose that Rembrandt had any aversion to duplicating a successful composition.

44

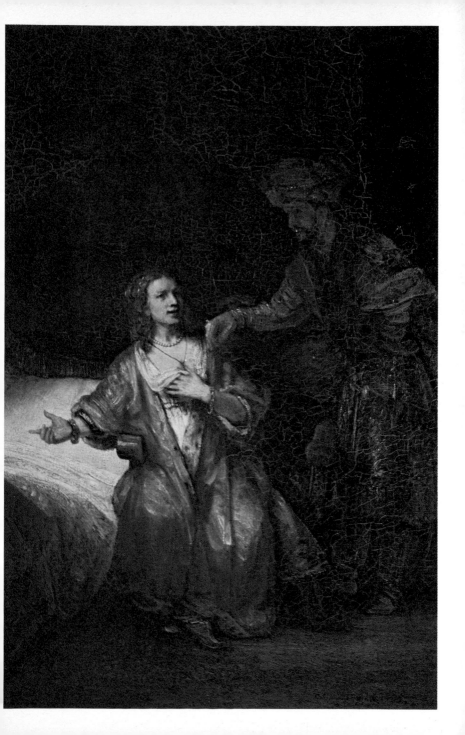

279 'The Polish Rider'
Oil on canvas/115 × 135.5/
c.1653–5
New York, The Frick
Collection

280 Hendrickje Bathing
Oil on panel/62 × 47/s.d.1654
London, National Gallery

281 Hendrickje as Flora
Oil on canvas/100 × 92/
c.1654–5
New York, Metropolitan
Museum of Art

**282 A Young Woman at a
Mirror**
Oil on panel/39.5 × 32.5/
s.d.165(4?)
Leningrad, Hermitage

283 An Old Man with a Beret
Oil on canvas/74 × 65/
s.d.1654
Pendant to No. 284.
Moscow, Pushkin Museum

The Slaughtered Ox (No. 302)
*Rembrandt very rarely painted
still-life but he did paint the
subject of a Slaughtered Ox
twice, in this painting and in
another in the Glasgow
Museum which was painted
c.1637–40. This later version
has always had a special
reputation among painters for
the superlative rendition of the
texture of the flesh. There are
copies of it by Delacroix,
Bonvin and Soutine. The motif
was also used by Daumier.*

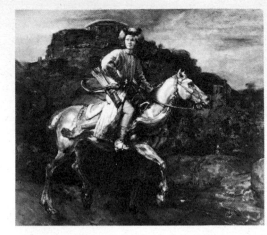

279

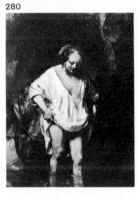

280

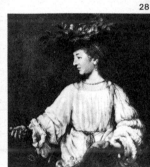

28

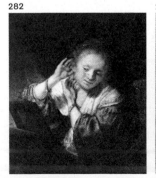

282

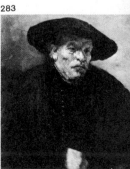

283

46

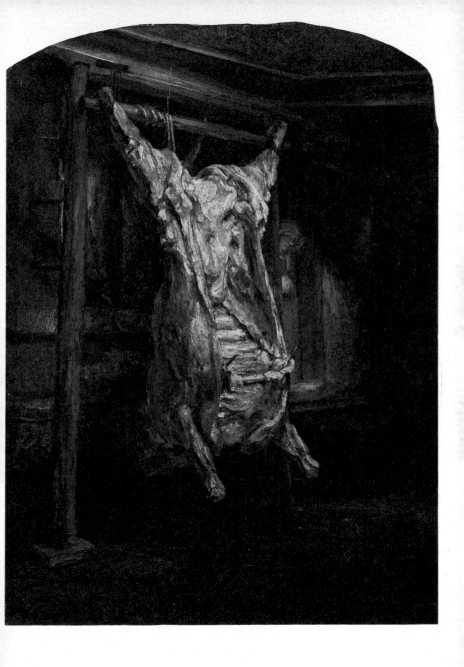

284 An Old Woman with a Hood
Oil on canvas/74 × 63/
s.d.1654
Pendant to No. 283.
Moscow, Pushkin Museum

285 Jan Six
Oil on canvas/112 × 102/
Dated 1654 in a poem written
by Six about the portrait.
Amsterdam, Six Foundation

286 Self-Portrait
Oil on canvas/73 × 60/
s.d.165(4?)
Pendant to No. 287.
Kassel, Gemäldegalerie

287 Hendrickje Stoffels
Oil on canvas/72 × 60/
d.165(4?)
Pendant to No. 286.
Paris, Louvre

288 Old Woman in an Armchair
Oil on canvas/109 × 84/
s.d.1654
Enlarged. Pendant to
No. 289.
Leningrad, Hermitage

289 Old Man in an Armchair
Oil on canvas/109 × 84.8/
s.d.1654
Enlarged. Pendant to
No. 288.
Leningrad, Hermitage

Titus at his Desk (No. 309)
*Rembrandt's son, Titus, was
born in 1641 and his childhood
and adolescence were lovingly
chronicled by his father. The
jaw with its prominent chin,
the deep-set eyes, small mouth,
button nose and curly hair are
the principal features which
can be seen in all the portraits.
This picture, showing the 14-
year-old Titus dreaming at his
desk, is without doubt
Rembrandt's most delightful
account of childhood.*

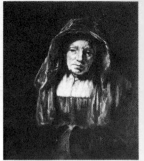
284

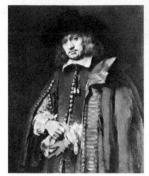
285

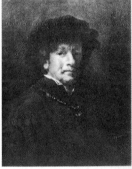
286

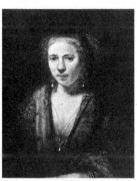
287

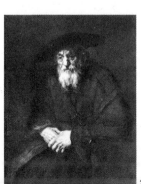
288

289

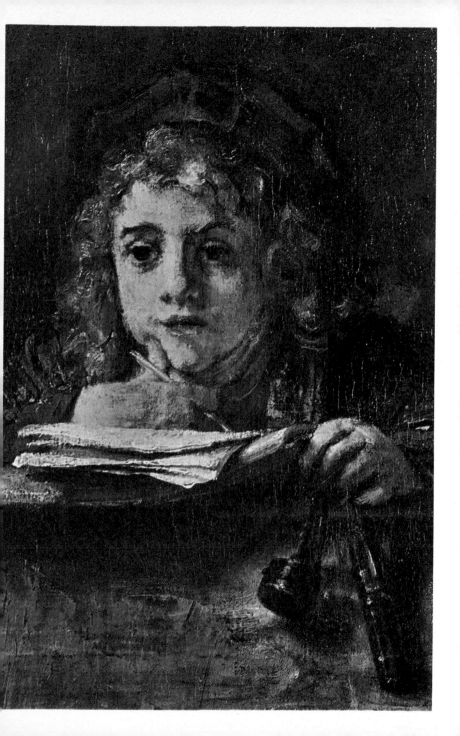

Jacob blessing the sons of Joseph *(No. 310)*

The moment represented by Rembrandt is described in Genesis, 48: 17–19.

Rembrandt shows Jacob with his hand on the head of Ephraim, the larger, fair-haired child, from whom, according to contemporary belief, the Gentiles traced their descent. The submissive gesture of Ephraim's crossed hands, Joseph's tender regard for his father, Manasseh's intense gaze towards his brother, are all described in strong, broad, brush strokes. The composition is strengthened and balanced by the presence of Joseph's wife, Asenath.

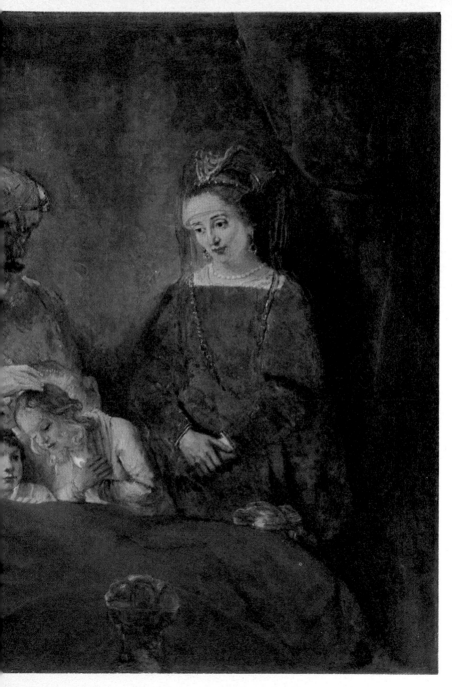

290 Old Man in an Armchair
Oil on canvas/108 × 86/s./
c.1654
Pendant to No. 291.
The attribution is doubtful.
Leningrad, Hermitage

291 Old Woman in an Armchair
Oil on canvas/82 × 72/
s.d.16(..)/c.1654
Pendant to No. 290.
The attribution is doubtful.
Moscow, Pushkin Museum

292 Man in a Fur-lined Coat
Oil on canvas/114 × 87/s./
c.1654–6
Toledo, Ohio, Museum of
Art

293 The Standard Bearer
Oil on canvas
140.5 × 115/s.d.1654
New York, Metropolitan
Museum of Art

294 Evening Landscape with Cottages
Oil on panel/25.5 × 39.5/
s.d.1654
Montreal, Museum of Fine
Arts

295 River Landscape with Ruins
Oil on panel/67 × 87.5/s./
c.1654
Kassel, Gemäldegalerie

296 Bathsheba
Oil on canvas/142 × 142/
s.d.1654
Paris, Louvre

297 Danae
Oil on canvas/185 × 203/
Though it bears the date
1636, the painting was
substantially repainted
c.1654.
Leningrad, Hermitage

298 Christ and the Woman of Samaria
Oil on panel/46.5 × 39/
s.d.1655
Berlin-Dahlem,
Gemäldegalerie

290

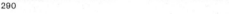
291

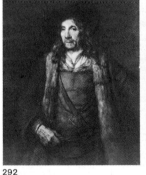
292

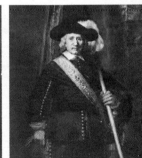
293

294

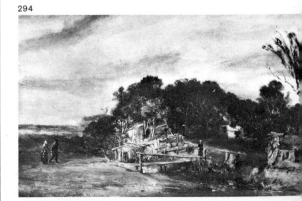

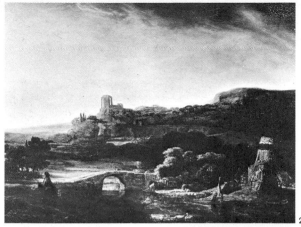

295

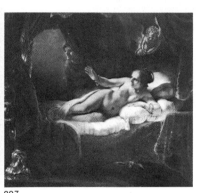

297

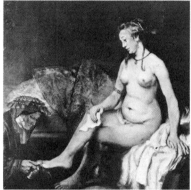

296

298

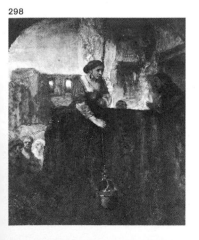

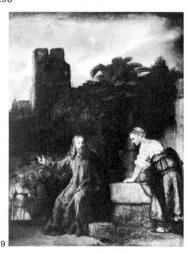

299

299 Christ and the Woman of Samaria
Oil on panel/62 × 49.5/
s.d.1655
New York, Metropolitan Museum of Art

300 Joseph accused by Potiphar's wife
Oil on canvas/110 × 87/
s.d.1655
Berlin-Dahlem, Gemäldegalerie

301 Joseph accused by Potiphar's wife
Oil on canvas/106 × 98/
s.d.1655
Washington, National Gallery of Art

302 The Slaughtered Ox
Oil on panel/94 × 67/s.d.1655
Paris, Louvre

303 An Old Woman Reading
Oil on canvas/79.5 × 66.5/
s.d.1655
Drumlanrig, Scotland, Collection of the Duke of Buccleuch

304 Self-Portrait
Oil on panel/66 × 53/s.d.1655
Vienna, Kunsthistorisches Museum

The Anatomy Lesson of Dr Joan Deyman (detail)
(No. 311)
This is a detail of the fragment that remains of the second Anatomy Lesson painted by Rembrandt. Like the first, the ANATOMY LESSON OF DR TULP, *it hung in the Anatomy Theatre in Amsterdam, where it was partially destroyed by fire in 1723. A drawing by Rembrandt, which seems to have been made to indicate an appropriate frame, is the only surviving evidence of the original composition. Dr Deyman began, as was usual in a public dissection, with the stomach cavity and has now exposed the brain.*

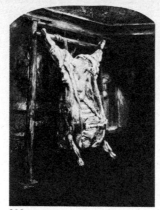
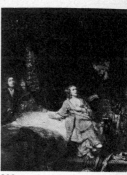

302 300

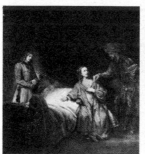

301 303

304 305

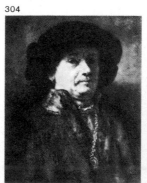

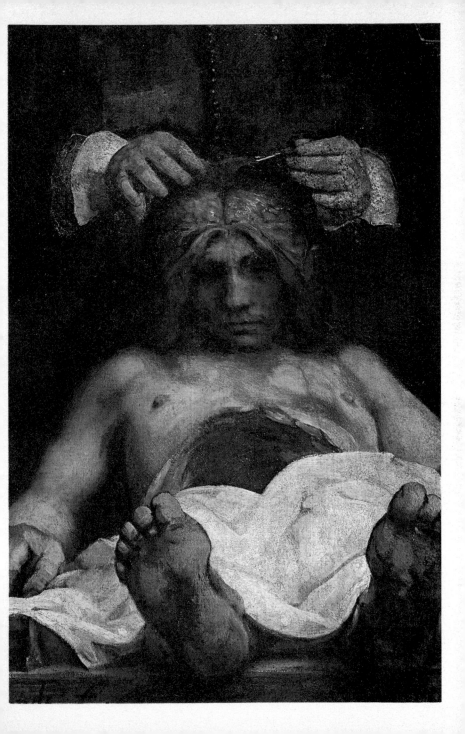

305 Christ
Oil on panel/24.5 × 20/c.1655
Philadelphia, Johnson
Collection

306 Christ
Oil on panel/25.2 × 19.9/
c.1655
Cambridge, Mass., Fogg Art
Museum

307 Christ
Oil on panel/25 × 20/c.1655
Berlin-Dahlem,
Gemäldegalerie

308 Self-Portrait
Oil on panel/49.2 × 41/s./
c.1655–7
Vienna, Kunsthistorisches
Museum

309 Titus at his Desk
Oil on canvas/77 × 63/
s.d.1655
Rotterdam, Museum
Boymans-van Beuningen

**310 Jacob blessing the sons of
Joseph**
Oil on canvas/175.5 × 210.5/
s.d.1656
Kassel, Gemäldegalerie

306

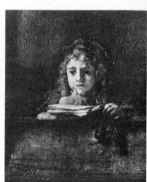

307

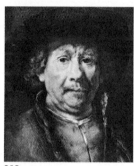

308

309

**The Apostle Paul at his Desk
(No. 316)**
*Paul's attribute, a sword,
hangs on the wall beside his
desk. Rembrandt painted
several half-length figures of
apostles in the late 1650s and
early 1660s. They have been
said to be a series but this
seems unlikely in view of the
differences in quality and the
variations in size. This is one
of the finest of these studies.*

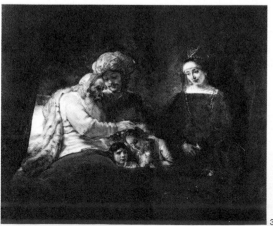

310

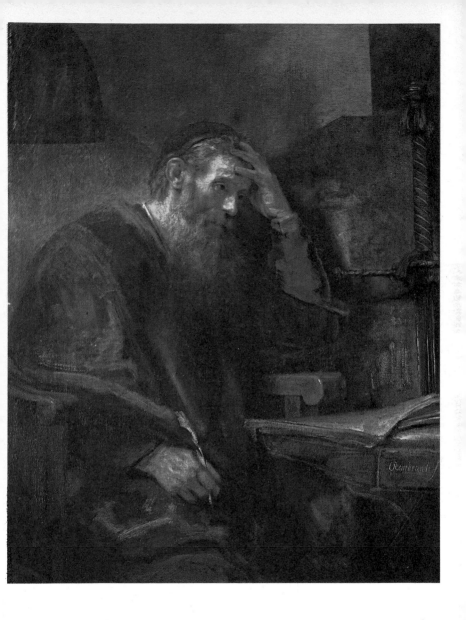

311 The Anatomy Lesson of Dr Joan Deyman
Oil on canvas/100 × 134/
s.d.1656
Fragment.
Amsterdam, Rijksmuseum

312 Arnout Tholinx
Oil on canvas/76 × 63/
s.d.1656
Paris, Musée Jacquemart-
André

313 A Young Man with a Beret
Oil on canvas/76 × 61/s./
c.1656
New York, collection of Mr
and Mrs C. S. Payson

314 Portrait of a Woman (Hendrickje?)
Oil on canvas/65.5 × 54/
c.1656
Los Angeles, Collection of
Mrs Norton Simon
(on loan to the National
Gallery of Art, Washington)

315 The Apostle Bartholomew
Oil on canvas/123 × 99.5/
s.d.1657
San Diego, Timken Gallery
of Art

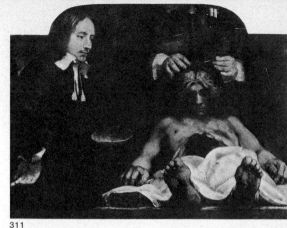

311

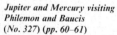

312

313

Jupiter and Mercury visiting Philemon and Baucis
(*No. 327*) (*pp. 60–61*)
This subject is very unusual in Dutch art. The story is told by Ovid. Philemon and his wife Baucis were simple Phrygian country people who entertained Jupiter and Mercury in their cottage when the gods were travelling in disguise and had been refused hospitality elsewhere.
Although the subject comes from classical mythology, its message is of Christian charity and for this reason appealed to Rembrandt and his contemporaries.

314

315

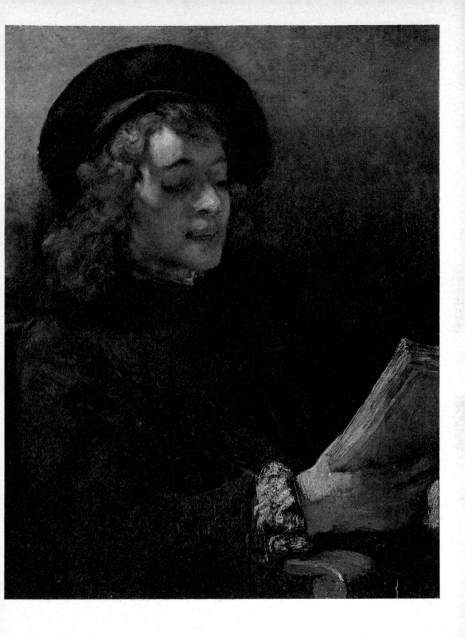

Titus Reading (*No. 325*)
Titus is here shown at the age of about 16. During the difficult years of Rembrandt's bankruptcy and sale, he was a great source of strength to his father. He and Hendrickje formed a company to market the artist's work, without which Rembrandt could not have continued painting.

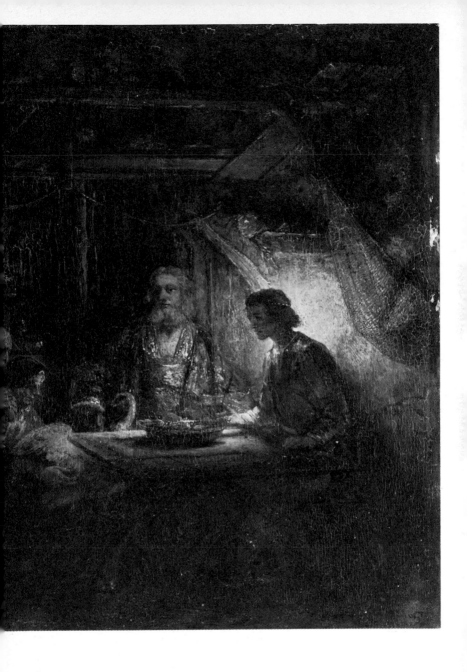

61

316 The Apostle Paul at his Desk
Oil on canvas/129 × 102/s./
c.1657
Washington, National
Gallery of Art

317 A Bearded Man
Oil on canvas/70.5 × 58/
c.1657
Berlin-Dahlem,
Gemäldegalerie

318 The Apostle Paul
Oil on canvas/102 × 85.5/
s.d.165(.)/c.1657
London, National Gallery

319 Self-Portrait
Oil on canvas/53 × 43.5/
s.d.1657
Edinburgh, National Gallery
of Scotland

320 Titus
Oil on canvas/67 × 55/c.1657
London, Wallace Collection

321 A Young Woman with a Carnation
Oil on canvas/78 × 68.5/
c.1657
Copenhagen, Statens
Museum for Kunst

316　　　　　　317

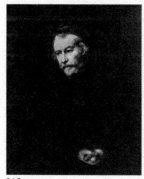
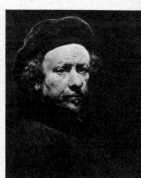

318　　　　　　319

320　　　　　　321

Hendrickje at an open door (No. 330)
Hendrickje is posed here half-length, turned slightly to the left, leaning against the upper frame of a door. The lower half of the door is closed and she rests her left arm on it. The composition betrays the influence of the Venetian High Renaissance painter Palma Vecchio.

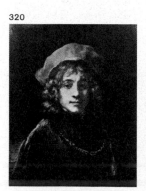

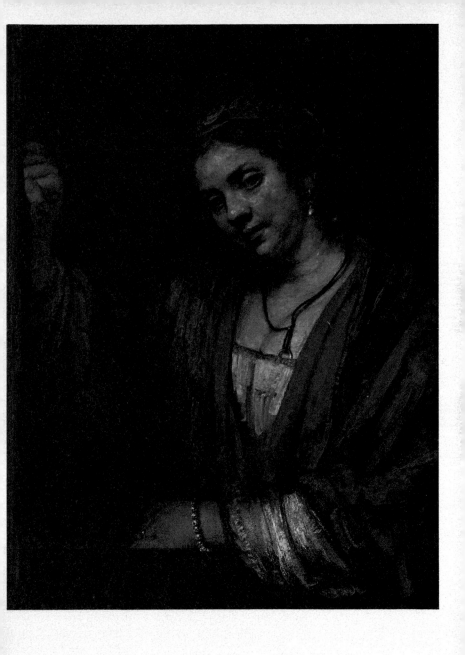

322 An Old Man with a Gold Chain
Oil on canvas/78.5 × 65.5/ s.d.1657
San Francisco, California, Palace of the Legion of Honor

323 An Old Man in a Cape
Oil on canvas/81.5 × 64.5/ c.1657
Kenosha, Wisconsin, Collection of Mr R. Whitacker

324 A Bearded Man in a Cap
Oil on canvas/78 × 66.5/ c.1657
London, National Gallery

325 Titus Reading
Oil on canvas/70.5 × 64/ c.1657
Vienna, Kunsthistorisches Museum

326 Catrina Hooghsaet
Oil on canvas/125.5 × 98.5/ s.d.1657
Penrhyn Castle, Wales, Collection of Lady Janet Douglas-Pennant

325

322

323

Self-Portrait (No. 334)
Rembrandt shows no trace of his financial difficulties in this superbly assertive self-portrait. Although only 52, he has cast himself in the role of the elderly, respected master painter. It is a remarkably accomplished piece of painting. The broad strokes are brushed onto the canvas with absolute confidence and difficult passages like the left hand holding the stick are achieved effortlessly.

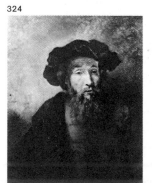
324

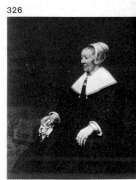
326

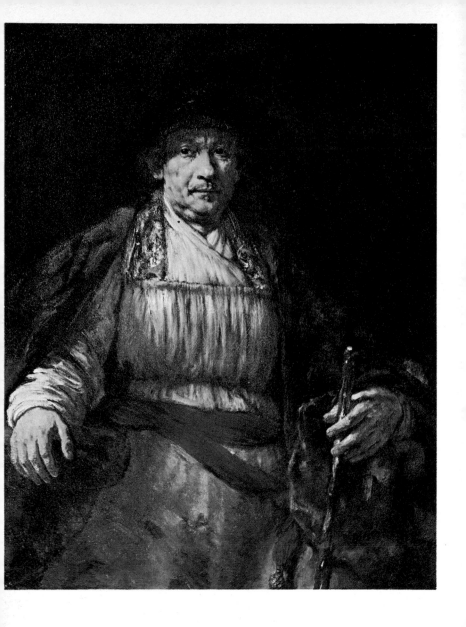

65

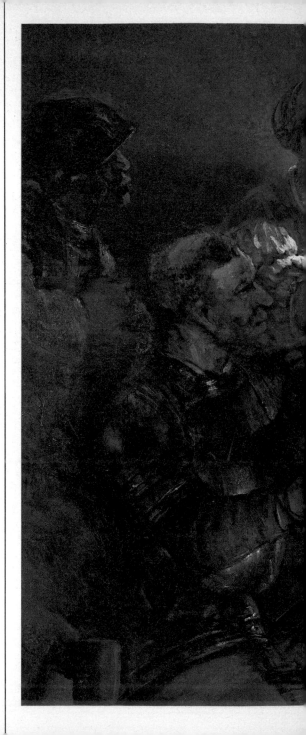

327 Jupiter and Mercury visiting Philemon and Baucis
Oil on panel/54.5 × 68.5/
s.d.1658
Washington, National
Gallery of Art

328 A Young Woman
Oil on canvas/56.5 × 47.5/
c.1658
Montreal, Museum of Fine
Arts

329 Portrait of a Man
Oil on canvas/82.5 × 64.5/
c.1658
New York, Metropolitan
Museum of Art

330 Hendrickje at an open door
Oil on canvas/86 × 65/c.1658
Berlin-Dahlem,
Gemäldegalerie

331 A Man holding a manuscript
Oil on canvas/108.5 × 86.5/
s.d.1658
New York, Metropolitan
Museum of Art

332 A Man holding a letter
Oil on canvas/113 × 95.5/
s.d.1658
Switzerland, Private
Collection

333 A Man with his hand on his hips
Oil on canvas/106.5 × 87.5/
s.d.1658
New York, Columbia
University

The Denial of St Peter (No. 344)
In his later religious paintings, Rembrandt tended to abandon the background scenes which had reinforced the narrative in earlier paintings and to favour plain backgrounds. On this occasion, however, the scene gains additional pathos from the fact that we can recognize the betrayed Christ as the central figure in the group in the background.

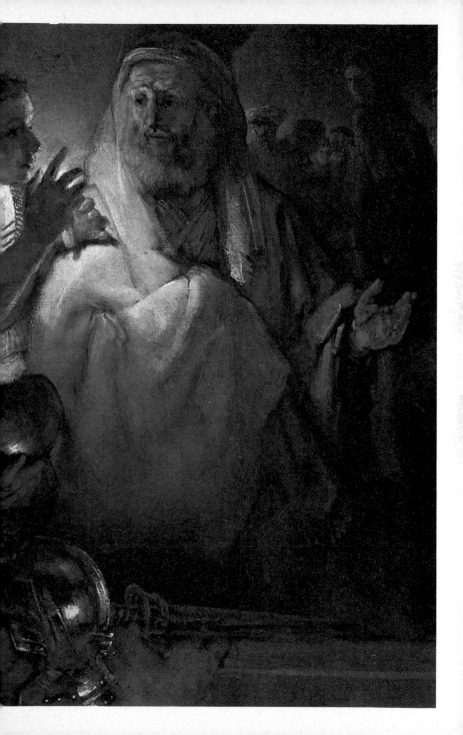

334 Self-Portrait
Oil on canvas/133.5 × 104/
s.d.1658
New York, The Frick
Collection

**335 Moses with the Tablets of
the Law**
Oil on canvas/167 × 135/
s.d.1659
Berlin-Dahlem,
Gemäldegalerie

**336 Jacob wrestling with the
angel**
Oil on canvas/137 × 116/s./
c.1659
Berlin-Dahlem,
Gemäldegalerie

**337 Old Anna and Tobit wait
for their son**
Oil on panel/40.3 × 54/
s.d.1659
Rotterdam, Museum
Boymans-van Beuningen

**338 Christ and the Woman of
Samaria**
Oil on canvas/60 × 75/
s.d.1659
Leningrad, Hermitage

339 Self-Portrait
Oil on canvas/84.5 × 66/
s.d.1659
Washington, National
Gallery of Art

340 Titus
Oil on canvas/72 × 56/c.1659
Paris, Louvre

341 An Old Man
Oil on panel/37.5 × 26.5/
s.d.1659
Birmingham, England,
Collection of Mr D. Cotton

**342 Haman and Ahasuerus at
the feast of Esther**
Oil on canvas/73 × 94/
s.d.1660
Moscow, Pushkin Museum

**343 The Risen Christ at
Emmaus**
Oil on canvas/48 × 64/c.1660
Paris, Louvre

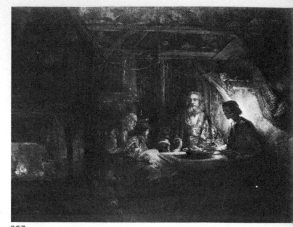

327

328

329

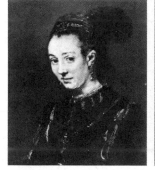

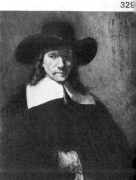

330

33

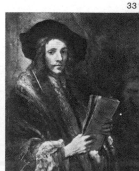

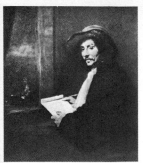
332

333

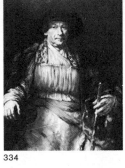
334

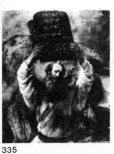
335

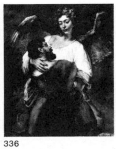
336

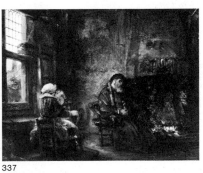
337

338

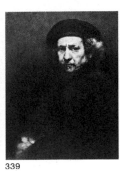
339

340

341

342

343

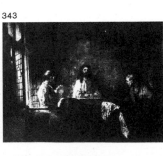

344 The Denial of St Peter
Oil on canvas/154 × 169/
s.d.1660
Amsterdam, Rijksmuseum

345 Self-Portrait
Oil on canvas/80.5 × 67.5/
s.d.1660
Pendant to No. 346.
New York, Metropolitan
Museum of Art

346 Hendrickje Stoffels
Oil on canvas/78.5 × 69/
s.d.1660
Pendant to No. 345.
New York, Metropolitan
Museum of Art

347 Self-Portrait
Oil on canvas/111 × 85/
s.d.1660
Paris, Louvre

348 Portrait of a Young Man
Oil on canvas/93 × 87.5/
s.d.1660
Rochester, New York,
University Collection

349 Man seated before a stove
Oil on panel/48 × 41/c.1660
Winterthur, Switzerland,
Oskar Reinhart Collection

350 Study of an Old Man
Oil on panel/24.5 × 19/c.1660
New York, Whitney
Collection

Self-Portrait (detail) (No. 347)
In this self-portrait of 1660,
Rembrandt has abandoned the
flamboyance of dress and the
commanding pose of the SELF-
PORTRAIT *of two years before*
(No. 334). He is standing
before his easel, paintbrushes,
palette and maulstick in hand.
He is dressed in his smock
with a scarf tied around his
forehead like a turban. His
face is expressionless. It is an
absolutely candid exercise in
self-observation.

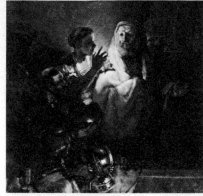

344

345

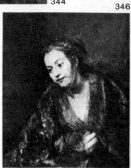

346

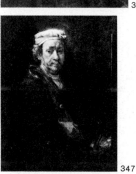

347

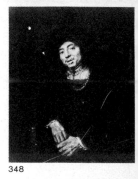

348

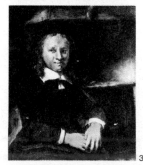

349

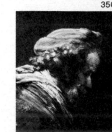

350

70

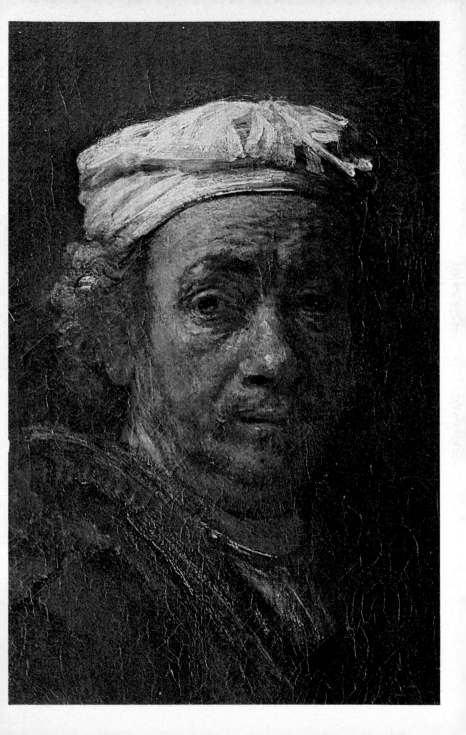

351 Hendrickje Stoffels
Oil on canvas/100 × 83.5/
c.1660
London, National Gallery

352 Titus in Monk's Habit
Oil on canvas/79.5 × 67.7/
s.d.166(0?)
Amsterdam, Rijksmuseum

**353 Alexander the Great
(Athena?)**
Oil on canvas/118 × 91.1/
c.1661
Lisbon, Museu Calouste
Gulbenkian

354 Alexander the Great
Oil on canvas/115.5 × 87.5/
c.1655–61
Glasgow, Art Gallery and
Museum

**355 The Circumcision of
Christ**
Oil on canvas/56 5 × 75/
s.d.1661
Washington, National
Gallery of Art

**356 The Conspiracy of Julius
Civilis: The Oath**
Oil on canvas/196 × 309/
Documented as having been
painted in 1661.
Fragment.
Stockholm, Nationalmuseum

351 352

353 354

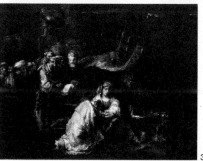

355

**Titus in Monk's Habit
(No. 352)**
*Rembrandt used his 19-year-
old son as the model for this
study of a young monk. It is
painted broadly and
confidently in the artist's late
style. One of the most striking
characteristics of this style is
that Rembrandt is more
interested in the painted
surface of the picture than in
the purely descriptive function
of the paint. In this case, the
form of the monk's habit is
difficult to make out but the
painted surface is continually
exciting to the eye.*

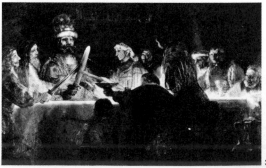

356

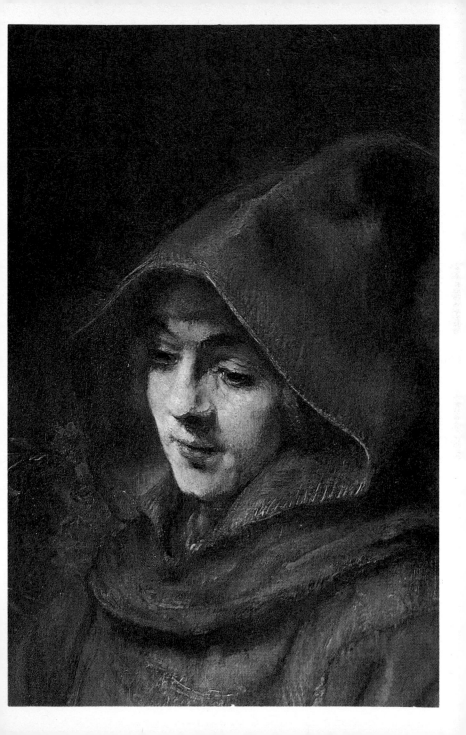

357 The Evangelist Matthew inspired by the Angel
Oil on canvas/96 × 81/
s.d.1661
Paris, Louvre

358 The Risen Christ
Oil on canvas/78.5 × 63/
s.d.1661
Munich, Alte Pinakothek

359 The Apostle James
Oil on canvas/90 × 78/
s.d.1661
New York, Metropolitan
Museum of Art

360 The Apostle Simon
Oil on canvas/98.3 × 79/
s.d.1661
Zürich, Kunsthaus

361 An Evangelist writing
Oil on canvas/102 × 80/c.1661
Rotterdam, Museum
Boymans-van Beuningen

362 An Evangelist writing
Oil on canvas/104.5 × 84/
s.d.166(.)/c.1661
Boston, Museum of Fine Arts

363 An Apostle praying
Oil on canvas/87.5 × 72.5/
c.1661
Cleveland, Museum of Art

364 The Apostle Bartholomew
Oil on canvas/87.5 × 75/
s.d.1661
Malibu, California, Getty
Museum

365 The Virgin Mary
Oil on canvas/107 × 81/
s.d.1661
Epinal, France, Musée des
Vosges

366 Christ
Oil on canvas/108 × 89/c.1661
Glens Falls, New York, The
Hyde Collection

367 Christ
Oil on canvas/95.5 × 81.5/
s.d.1661
New York, Metropolitan
Museum of Art

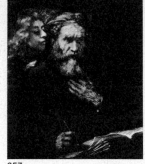

357

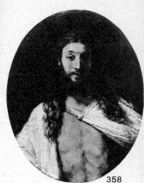

358

359

360

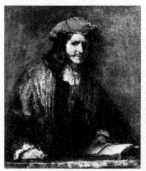

361

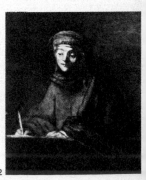

362

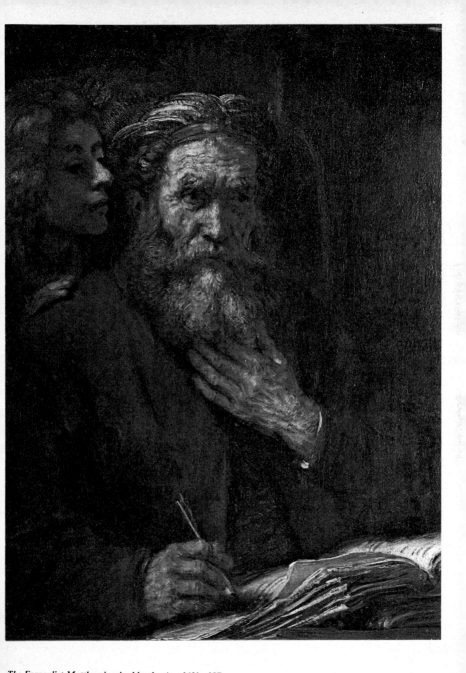

The Evangelist Matthew inspired by the Angel (No. 357)
This painting belongs, with THE APOSTLE PAUL *(No. 316), to the group of half-length apostles from the late 1650s and early 1660s. This is one of the best preserved of the group. The model for the angel, St Matthew's attribute, was Rembrandt's son, Titus.*

368 Man with a Falcon
Oil on canvas/98 × 79/c.1661
Gothenburg, Sweden,
Konstmuseum

369 Christ
Oil on panel/62 × 49/c.1661
Formerly Milwaukee,
Wisconsin, Collection of Mr
H. John

370 Jacob Trip
Oil on canvas/130.5 × 97/s./
c.1661
Pendant to No. 371.
London, National Gallery

*371 Margaretha de Geer, wife
of Jacob Trip*
Oil on canvas/130.5 × 97.5/
c.1661
Pendant to No. 370.
London, National Gallery

372 Margaretha de Geer
Oil on canvas/75.5 × 64/
s.d.1661
London, National Gallery

*373 A Capuchin Monk
reading*
Oil on canvas/82 × 66/
s.d.1661
Helsinki, Atheneum

374 Head of an Old Man
Oil on panel/24.5 × 20/c.1661
Great Britain, Private
Collection

*375 Portrait of an Old
Woman*
Oil on canvas/77 × 64/
s.d.1661
New York, Collection of Mrs
R. W. Straus

376 Two Negroes
Oil on canvas/77.8 × 64.4/
s.d.1661
The Hague, Mauritshuis

377 A Man in an Armchair
Oil on canvas/104.7 × 86/
s.d.166(.)/c.1661
Florence, Uffizi

378 Portrait of a Young Jew
Oil on canvas/64 × 57/
s.d.1661
Montreal, Collection of Mrs
William van Horne

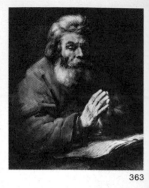

363

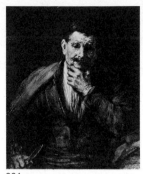

364

366

365

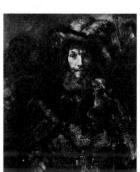

368

367

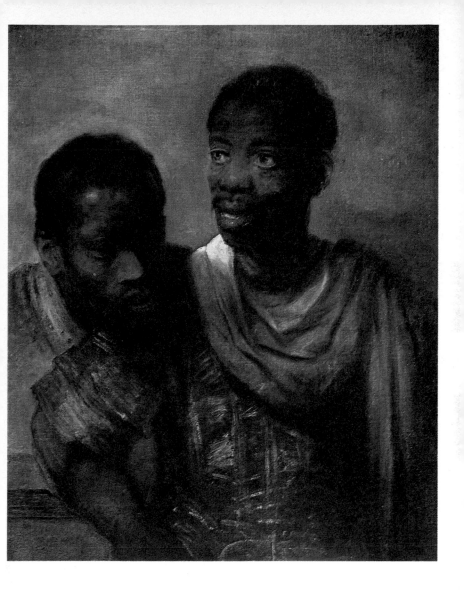

Two Negroes (No. 376)
This painting, which is clearly dated 1661, has been identified with an item in Rembrandt's inventory of 1656:
Twee Mooren in een stuk van Rembrandt *(Two moors in a painting by Rembrandt). However, the style is*
perfectly consistent with the date on the picture and both the date and the signature appear to be authentic. It is
possible that the two negroes were dressed and posed to be included in a larger history painting, for which this
was a preliminary study. On the other hand, no such painting has survived.

379 A Bearded Man
Oil on canvas/71 × 61/
s.d.1661
Leningrad, Hermitage

380 Man in a Tall Hat
Oil on canvas/121 × 94/
c.1661–2
Washington, National
Gallery of Art

381 Dirk van Os
Oil on canvas/103.5 × 86.5/
c.1660–2
Omaha, Nebraska, Joslyn Art
Museum

382 Self-Portrait as the Apostle Paul
Oil on canvas/91 × 77/
s.d.1661
Amsterdam, Rijksmuseum

383 The Staalmeesters (The Sampling Officials of the Drapers' Guild)
Oil on canvas/191 × 279/
s.d.1662
Amsterdam, Rijksmuseum

384 Portrait of a Young Man
Oil on canvas/90 × 71/
s.d.166(2?)
St Louis, Missouri, City Art
Museum

385 A Woman with a lap dog
Oil on canvas/80.5 × 64/
c.1662
Toronto, Art Gallery of
Ontario

386 Self-Portrait
Oil on canvas/85 × 61/
c.1662–5
Florence, Uffizi

387 Homer
Oil on canvas/108 × 82.4/
s.d.1663
Fragment.
The Hague, Mauritshuis

388 Portrait of a Young Man
Oil on canvas/110 × 90/
s.d.1663
Washington, National
Gallery of Art

389 Portrait of Titus
Oil on canvas/73 × 60/
c.1663–4
London, Dulwich College Art
Gallery

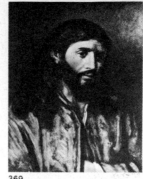
369

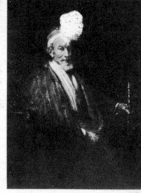
370

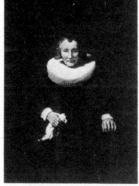
371

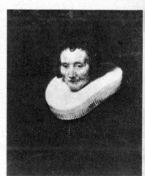
372

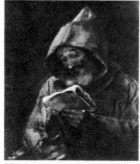
373

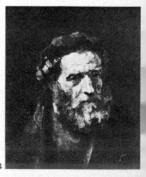
374

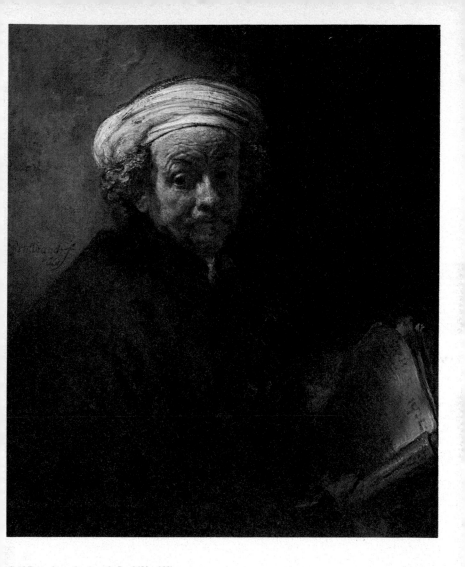

Self-Portrait as the Apostle Paul (*No. 382*)
This painting, a St Paul 'in disguise', belongs to the group of late half-length apostles. Paul's attributes of a sword and a book represent the dual allegiances of the vita attiva *(active life) and the* vita contemplativa *(contemplative life). By using himself as the model for St Paul, Rembrandt was identifying himself with the apostle's inner conflict.*

The Staalmeesters (***The Sampling Officials of the Drapers' Guild***) (*No. 383*) (*pp. 80–81*)
The steep viewpoint of the picture was contrived to accord with the position in which it was to hang. The man rising from his chair is not about to address a public meeting. His pose is simply a compositional device to make the portrait more immediate. The book which provides a focus for the composition is a sample book of cloth which acted as a standard for judging other cloths, and it was the maintenance of this standard that the officials were appointed to ensure. The whole painting is a symbol of good citizenship and good government.

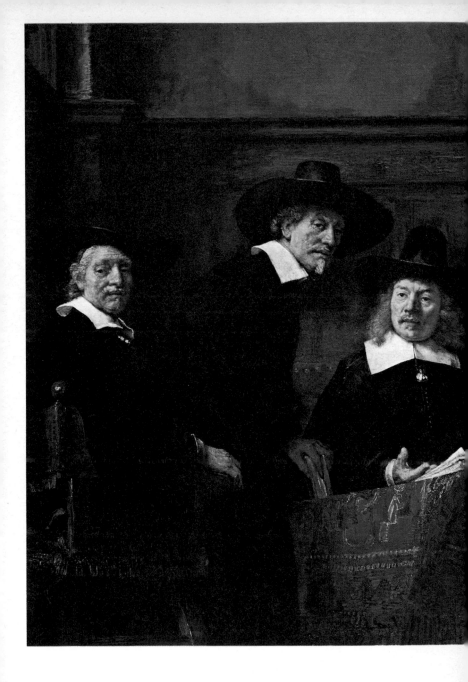

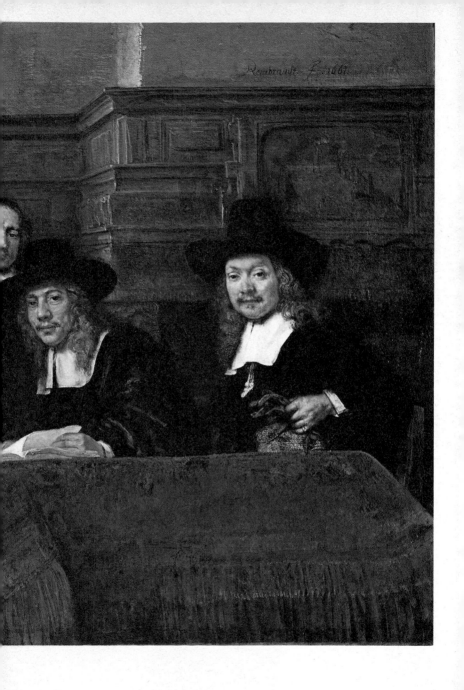

390 Frederik Rihel on horseback
Oil on canvas/282 × 248/
s.d.1663
London, National Gallery

391 Lucretia
Oil on canvas/120 × 101/
s.d.1664
Washington, National
Gallery of Art

392 Gerard de Lairesse
Oil on canvas/112 × 87/
s.d.1665
New York, Metropolitan
Museum of Art

393 Lucretia
Oil on canvas/105 × 92.5/
s.d.1666
Minneapolis, Institute of Arts

394 Juno
Oil on canvas/127 × 123/
c.1664–6
Los Angeles, Armand
Hammer Foundation

395 Self-Portrait
Oil on canvas/114.5 × 94/
c.1666
London, Kenwood House,
The Iveagh Bequest

396 Portrait of a Young Man
Oil on canvas/80.5 × 65/
s.d.1666
Kansas City, Missouri,
William Rockhill Nelson
Museum of Art

*A Woman holding an ostrich
feather fan (No. 399)*
*This superb portrait, of which
there is a pendant, A MAN
HOLDING GLOVES (No. 398), is
among the very last paintings
by the artist. It represents the
culmination of a lifetime's
portrait painting. As such, it is
important to note that it is not
Rembrandt's ability to lay
bare the sitter's soul that rivets
our attention but the sheer
beauty of the paint surface. It
is the transmutation of visual
appearance into scintillating
patterns of paint that is the
key to the greatness of
Rembrandt's portraiture.*

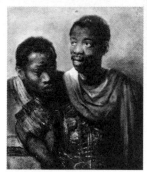
376

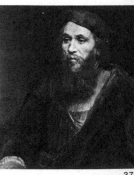
37

37

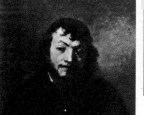

378

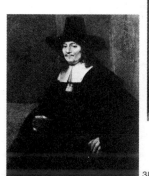
380

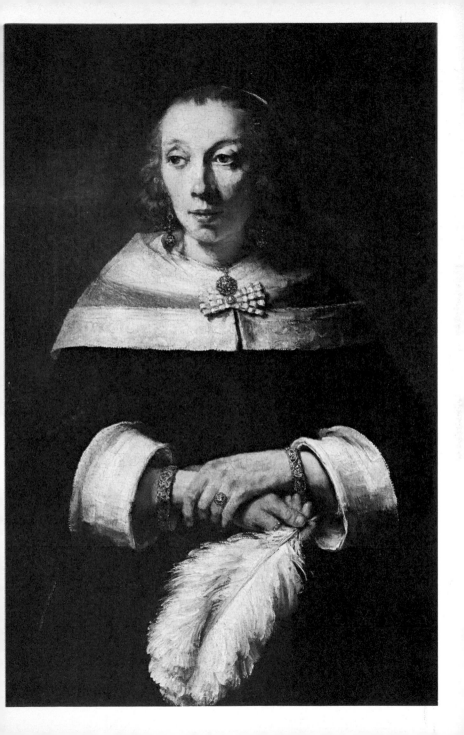

397 Jeremias de Dekker
Oil on panel/71 × 56/s.d.1666
Leningrad, Hermitage

398 A Man holding gloves
Oil on canvas/99.5 × 83.5/
*c.*1666–8
Pendant to No. 399.
Washington, National
Gallery of Art

399 A Woman holding an ostrich feather fan
Oil on canvas/100 × 83/
*c.*1666–8
Pendant to No. 398.
Washington, National
Gallery of Art

400 Portrait of an Old Man
Oil on canvas/82 × 67.5/
s.d.1667
Cowdray Park, Sussex,
Collection of Lord Cowdray

401 Portrait of a Fair-haired Man
Oil on canvas/102 × 83/
s.d.1667
Melbourne, National Gallery
of Victoria

402 A Family Group
Oil on canvas/126 × 167/
*c.*1667–8
Perhaps unfinished.
Brunswick, Herzog Anton
Ulrich Museum

A Family Group (No. 402) (pp. 86–7)
Despite the fact that the paint seems to have been flattened by an early relining of the canvas, and that it may not have been completely finished by Rembrandt, this picture remains among Rembrandt's finest portraits of his late years and shows a freedom of technique characteristic of that time. It is the style which Aert de Gelder, Rembrandt's last pupil, adopted and used to great effect in his own portraits, notably that of the great physician HERMAN BOERHAAVE AND HIS FAMILY *(Amsterdam, Rijksmuseum), which was painted in about 1722.*

381

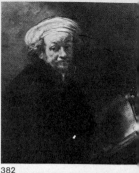

382

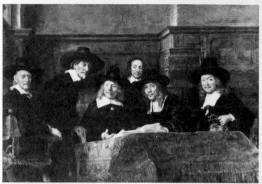

384

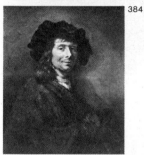

383

386

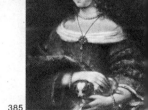

385

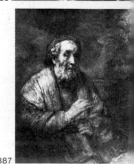

387

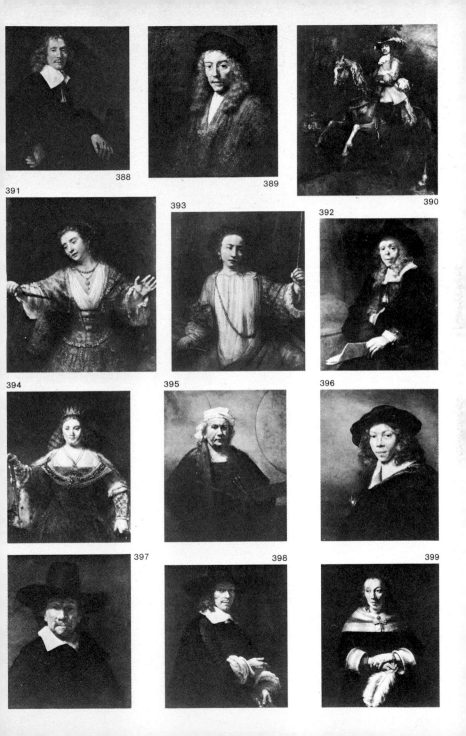

388

389

391

390

393

392

394

395

396

397

398

399

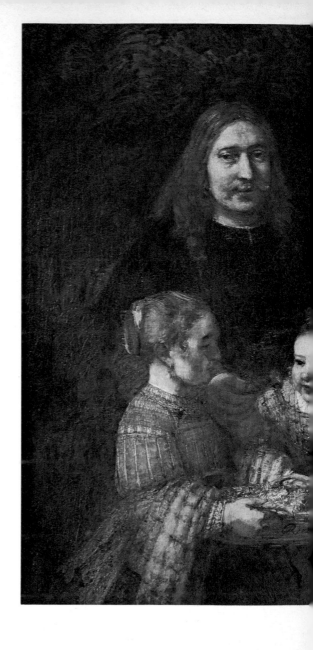

'The Jewish Bride' (No. 406) (pp. 90–91)

This title is a traditional one and there is no certainty about the picture's subject. There is a drawing by Rembrandt which represented the Biblical love story of Isaac and Rebecca (Genesis 26:8) which seems to have been the first idea for the tender pose of the couple. Whether the painting represents that Biblical story or whether it is a double portrait in the guise of the story is unclear. What is certain, however, is that the picture is a poignant depiction of mature love. Rembrandt applied the strong colours with the scrapes of a palette knife as much as with the broad strokes of the brush.

403 A Man with a magnifying glass
Oil on canvas/91.5 × 74.5/ c.1667–8
Pendant to No. 404.
New York, Metropolitan Museum of Art

404 A Woman with a carnation
Oil on canvas/92 × 74.5/ c.1667–8
Pendant to No. 403.
New York, Metropolitan Museum of Art

The Return of the Prodigal Son (detail) (No. 405)
Rembrandt's composition is monumental, the figures of father and son are joined together in a single whole while the onlookers are clearly deeply moved by the dishevelled and ragged figure seeking forgiveness. These figures stand apart, not partaking directly in the private drama. The reconciliation is not bound to a particular time or place, for a background setting is scarcely suggested by the artist at all.

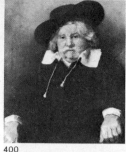

400

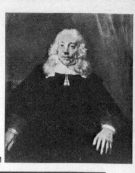

401

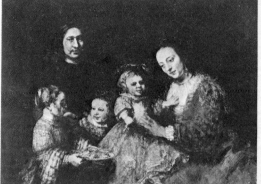

402

403

404

406

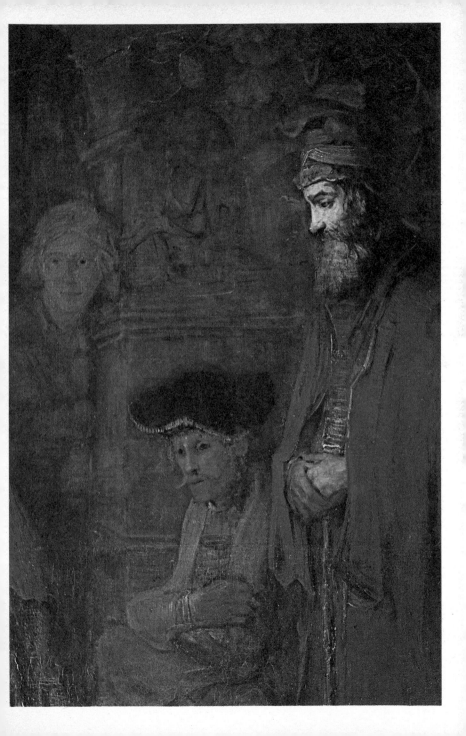

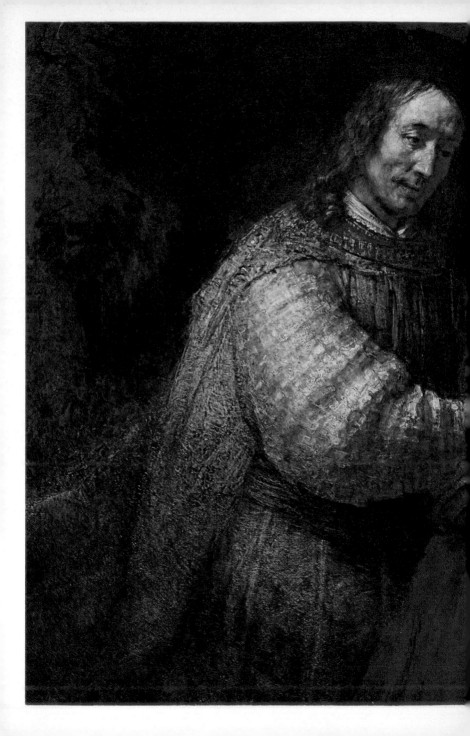

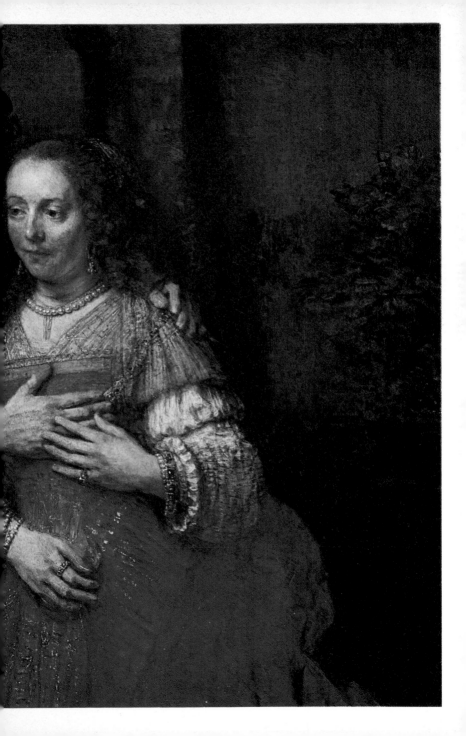

405 The Return of the Prodigal Son
Oil on canvas/262 × 206/
c.1667–8
Leningrad, Hermitage

406 'The Jewish Bride'
Oil on canvas/121.5 × 166.5/
s.d.16(..)/c.1667–8
Amsterdam, Rijksmuseum

407 The Disgrace of Haman
Oil on canvas/127 × 117/
c.1667–8
Leningrad, Hermitage

408 Simeon with the Christ Child in the Temple
Oil on canvas/98 × 79/
Probably left unfinished in
the artist's studio at the time
of his death in 1669.
Stockholm, Nationalmuseum

409 Self-Portrait
Oil on canvas/86 × 70.5/
s.d.1669
London, National Gallery

410 Self-Portrait
Oil on canvas/82.5 × 65.5/
c.1668–9
Cologne, Wallraf-Richartz
Museum

411 Self-Portrait
Oil on canvas/59 × 51/
s.d.1669
The Hague, Mauritshuis

Self-Portrait (No. 410)
*It has recently been argued
most convincingly that this
painting done in the broad
style of Rembrandt's last years
is a fragment of a larger
painting in which the artist
represented himself as the
legendary Greek painter
Zeuxis. Zeuxis 'is said to have
departed this life while
laughing immoderately,
choking while painting a
wrinkled, funny old woman in
the flesh'. (Carel van Mander,*
BOOK OF PAINTERS.)
*Rembrandt's painting
originally showed him laughing
while at work painting an old
woman, and this was the
source for a painting by Aert
de Gelder, his last pupil.*

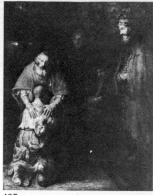
405

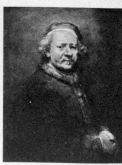
409

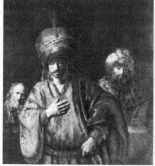
407

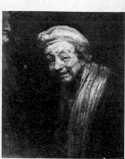
410

408
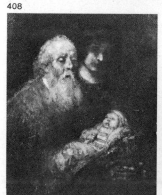

411

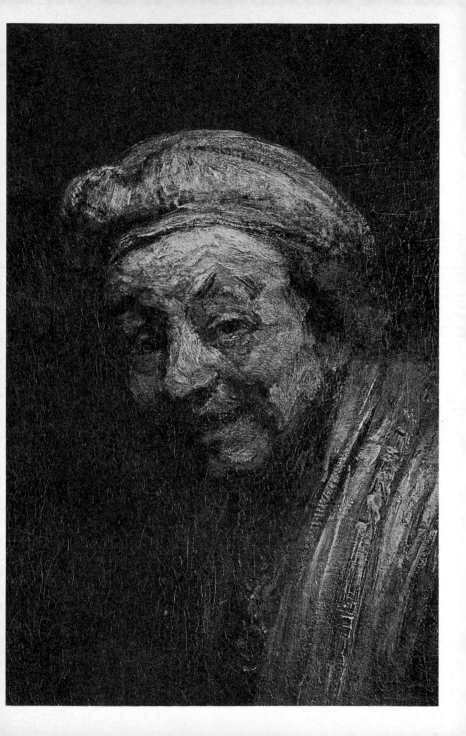

Rejected attributions

412 Tobit and Anna
Oil on panel/65.5 × 48.5/
By Gerrit Dou, perhaps after
a design by Rembrandt.
London, National Gallery

413 A Rabbi
Oil on panel/70 × 61/
Probably by Govaert Flinck.
Hampton Court Palace,
Royal Collection

414 The Sacrifice of Manoah
Oil on canvas/242 × 283/
By a pupil of Rembrandt,
perhaps Jan Victors.
Dresden, Gemäldegalerie

**415 Hendrick Martensz.
Sorgh**
Oil on panel/74 × 67/
s.d.164(?)
Pendant to No. 416.
London, Westminster
Collection

*Although Nos. 415 and 416
have been doubted the present
author believes them to be
entirely authentic.*

**416 Ariaentje Hollaer, wife of
Hendrick Martensz. Sorgh**
Oil on panel/74 × 67/s.d.1647
Pendant to No. 415.
London, Westminster
Collection

**417 The Man in the Golden
Helmet**
Oil on canvas/67 × 50/
By a pupil or early imitator
of Rembrandt.
Berlin-Dahlem,
Gemäldegalerie

418 Man in a Breast Plate
Oil on canvas/126 × 103/
By an imitator of Rembrandt.
Pendant to No. 419.
Cambridge, Fitzwilliam
Museum

419 Portrait of a Woman
Oil on canvas/134.5 × 101.5/
By an imitator of Rembrandt.
Pendant to No. 418.
Sarasota, Florida, Ringling
Museum of Art

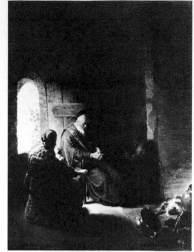
412

415

416

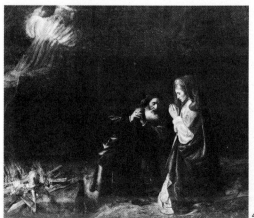
414

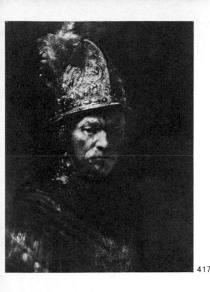

417

413

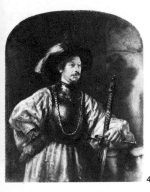

418

419

421

420

420 Young Girl holding a broom
Oil on canvas/107 × 91/
Washington, National
Gallery of Art

421 The Tribute Money
Oil on canvas/63 × 84
Perhaps by Gerbrand van den
Eeckhout.
Bywell, Northumberland,
Allendale Collection

Bibliography

General

JAKOB ROSENBERG: *Rembrandt* (Second revised edition, London, 1964).
CHRISTOPHER WHITE: *Rembrandt and his World* (London, 1964).
CHRISTIAN TÜMPEL: *Rembrandt* (Hamburg, 1977).

Paintings

HORST GERSON: *Rembrandt Paintings* (Amsterdam, 1968).
A. BREDIUS: *Rembrandt Paintings* (Third edition, revised by Horst Gerson, London, 1968).

Drawings

O. BENESCH: *The Drawings of Rembrandt* (6 volumes: second edition revised and enlarged by E. Benesch, London, 1973).
SEYMOUR SLIVE: *Drawings of Rembrandt* (2 vols, New York, 1965).

Etchings

CHRISTOPHER WHITE: *Rembrandt as an Etcher* (London, 1969).
CHRISTOPHER WHITE AND KAREL BOON: *Dutch and Flemish Etchings, Engravings and Woodcuts*, vol. XVIII (Hollstein series: Amsterdam, 1969).
G. SCHWARTZ (ed.): *All the Etchings of Rembrandt* (London/Maarssen, 1977).

Documents

HOFSTEDE DE GROOTE: *Die Urkunden über Rembrandt (1575–1721)* (The Hague, 1906).
SEYMOUR SLIVE: *Rembrandt and his Critics 1630–1730* (The Hague, 1953).
HORST GERSON: *Seven Letters by Rembrandt* (The Hague, 1961).

First published in the United States of America 1980
by Rizzoli International Publications, Inc.
712 Fifth Avenue, New York, New York 10019
Copyright © Rizzoli Editore 1979
This translation copyright © Granada Publishing 1980
Introduction copyright © Sir Ellis Waterhouse 1980
ISBN 0-8478-0269-8
LC 79-64899
Printed in Italy